American Sculpture

American Sculpture

The Collection of The Fine Arts Museums of San Francisco

by Donald L. Stover
Curator in Charge
Department of Decorative Arts and Sculpture

American Sculpture: The Collection of The Fine Arts Museums of San Francisco was published on the occasion of an exhibition at the California Palace of the Legion of Honor, July 31 - October 31, 1982.

Cover: *Diana,* 1889, by Frederick William MacMonnies (1863 - 1937). Bronze, H 29 in (73.7 cm). William H. Noble Bequest Fund, 1981.15

Back cover: *An Arcadian,* 1883, by Thomas Eakins (1844 - 1916). Bronze relief, H 8¼ in (21 cm). Gift of Mr. and Mrs. John D. Rockefeller 3rd, 1979.7.36

This exhibition and publication have been made possible by The Museum Society with generous grants from Mr. and Mrs. Bernard Osher and The Bernard Osher Foundation.

Contents

Acknowledgements

This exhibition and publication have been made possible by the generous support of Mr. and Mrs. Bernard Osher, The Bernard Osher Foundation, and The Museum Society. To Mr. and Mrs. Osher, the Directors of The Bernard Osher Foundation, and the Board of Directors of The Museum Society, I express my gratitude. Additionally, I would like to acknowledge the support and encouragement of Ednah Root, patron of the Ednah Root Curatorial Chair for American Art. I am also grateful to The Bothin Helping Fund whose support established The Bothin American Art Library Collection, which was essential to the preparation of this catalogue.

These museums are fortunate to have an exceptional staff, and I have greatly appreciated the talent, professionalism, and cooperation of those who contributed to the realization of this project. I am particularly indebted to Karen Carlson Sugarman who, as my research assistant, has been invaluable to the progress of every aspect of this undertaking. She joins me in acknowledging with gratitude the help and cooperation of the following individuals and institutions: Baird Archive of California Art, University of California, Davis; Bancroft Library, University of California, Berkeley; California Historical Society, San Francisco; Cincinnati Art Museum; Paul J. Karlstrom, West Coast Area Director, Archives of American Art, Smithsonian Institution; Mechanics' Institute Library, San Francisco; Morrison Planetarium, California Academy of Sciences, San Francisco; National Maritime Museum, San Francisco; The New-York Historical Society; The Oakland Museum; Oakland Public Library; Peabody Museum of Salem, Massachusetts; Presidio Army Museum, Presidio of San Francisco; San Francisco Art Institute; San Francisco Fire Department Pioneer Memorial Museum; San Francisco Public Library; Deborah Fenton Shepard; Martha Barnes Smith; Society of California Pioneers, San Francisco; State of California Division of Beaches and Parks, Sacramento; Sunset Magazine; Presidio of Monterey Museum; and Daniel Visnich, Senate Representative, Capitol Restoration Project, Sacramento.

The American sculpture now in the collection of The Fine Arts Museums of San Francisco represents the generosity of our founders and several generations of collectors, patrons, and donors. These museums and the communities that we serve are truly indebted to these individuals.

D.L.S.

Foreword

Sculpture always has been part of the collections of both the M. H. de Young Memorial Museum and the California Palace of the Legion of Honor. The primary interest was in the work of Europeans, but from time to time the work of Americans also was acquired. By 1921 the catalogue of the collection of the de Young Museum noted that "perhaps in no class of exhibit does the Memorial Museum possess a more representative collection than in examples of the sculptor's art." The prize was Gustave Doré's monumental bronze vase, eleven feet in height, *The Vintage*, which Michael de Young had obtained from the World's Columbian Exposition in Chicago for the California Midwinter International Exposition in San Francisco and later purchased for the museum for $10,000. The greatest part of the collection was exhibited in "Statuary Hall." In addition to plaster casts and bronze reproductions from the antique, works of the nineteenth-century American masters William Wetmore Story, Randolph Rogers, and Hiram Powers were juxtaposed with the contemporary work of Haig Patigian from San Francisco.

From the opening of the California Palace of the Legion of Honor in 1924, the personal passion for sculpture of its founder, Alma de Bretteville Spreckels, established a tradition of collecting and exhibiting contemporary sculpture that included the work of such American artists as Arthur Putnam and Malvina Hoffman, as well as that of Rodin. In 1926 that tradition was enhanced by the additional patronage of Archer M. Huntington, whose gifts to the collection included works by his wife, Anna Hyatt Huntington, and Frederick Roth, Harriet Frishmuth, Chester Beach, and Carl Jennewein.

Three years later, the Legion of Honor was host to one of the largest exhibitions of American sculpture ever assembled by a single institution. Organized by the National Sculpture Society under a grant from Archer M. Huntington, the installation filled the museum's galleries, fountain basin, and surrounding parkland, displaying 1,336 works by 286 contemporary American sculptors. This exhibition marked the apogee of the museum's patronage of American sculpture. In the decades that followed, the vagaries of taste, fashion, and modern art-historical criticism relegated most of the collection to storage or loan to other museums, historical societies, and institutions throughout Northern California.

Except for the purchase of Frederic Remington's *Bronco Buster* for the de Young in 1969 and the acquisition for the Legion of Honor of six of the light standards modeled by Arthur Putnam for Market Street's "Path of Gold," the fifty years between 1930 and 1981 were characterized by hardly any active collecting in this area. Nonetheless, the collection continued to grow by individual gifts and bequests, and significant works were included in the Theater and Dance Collection formed by Mrs. Spreckels at the Legion of Honor and in the acquisition of such important collections as those of Dr. T. Edward and Tullah Hanley, Mildred Anna Williams, Hélène Irwin Fagan, and Mr. and Mrs. John D. Rockefeller 3rd.

When the American Galleries were opened in 1977, the emphasis was on paintings. Only six pieces of sculpture were part of the first installation. As we shall see, the collection was by then sizeable but widely dispersed and out of mind. In the same year, Donald L. Stover joined the staff as the first curator specifically of American art. Happily, in 1981 during his tenure as Ednah Root Curator of American Art, he proposed a review and reevaluation of the museums' combined holdings in American sculpture. In the course of this project, the more than 300 works by sixty-two sculptors that comprise the collection of these museums were catalogued. In the time since, two new works have been acquired by purchase: *Winter* (ca 1825), from the studio of William Rush, and *Diana* (1889), by Frederick MacMonnies.

An outgrowth of this project, the present exhibition is a first step toward the reintegration of this important material into the exhibition program of these museums. It broadens the commitment of The Fine Arts Museums of San Francisco to the display and collection of the art of America.

Ian McKibbin White
Director of Museums

Introduction

The entire past of American culture is . . . comprised of a series of spurts forward. One day the desire mounts to break away from the banality of everyday life. But instead of progressing gradually, in accordance with general laws, the thrusts follow one another, at broken intervals, attempting to move, without transition, from the most rudimentary mores to the most extreme refinements. Aspirations go astray through inexperience, ending in the false glitter of intemperate luxury. This efflorescence has taken place in such a hasty and impetuous way that some observers have compared its results to the products of an overheated greenhouse—an apt comparison in many cases. But one very important point is thus missed: the rich exuberance of forced flowers has hidden the unobtrusive growth of a few young shoots breaking through the earth with fresh charm, which promise, when they bloom, the evolution of a new strain.
Samuel Bing, *La Culture Artistique en Amérique*, 1895*

This perceptive observation, written in the year in which the M. H. de Young Memorial Museum was founded, reflects a European perspective of American culture and at the same time offers an insight into the evolution of sculpture in America, and its representation in the collection of these museums in particular. Although neither the de Young Museum nor the California Palace of the Legion of Honor actively collected American sculpture as such, the work of American sculptors accumulated over the past eighty-seven years that now comprises the combined collection of The Fine Arts Museums of San Francisco provides the opportunity to survey American sculpture from its origins in the eighteenth-century craft traditions of the stone- and wood-carver, through the "rich exuberance" of the nineteenth century, to the emergence of the "new strains" that were to presage the modernism of the twentieth century.

The colonial experience in America provided little stimulus for the development of formal sculptural expression, but the crafts of stone carving and especially wood carving had become highly developed by the end of the eighteenth century. Although many of these craftsmen distinguished themselves in the carving of furniture, architectural ornament, and ship's figures, the few who succeeded in transcending the artisan tradition emerged as America's first native-born sculptors.

In the second quarter of the nineteenth century, American-born artists who aspired to become sculptors began to travel to Italy, studying for a time or settling permanently in Florence and Rome. There they were exposed to the sculpture and monuments of classical antiquity and influenced by the prevailing neoclassic tradition of Canova and Thorwaldsen. They modeled historical and allegorical figures that were then executed in white marble in the centuries-old shops of skilled Italian artisan stone-cutters. For two generations American sculptors trained or resident in Italy were to supply their homeland with public monuments and architectural sculpture, and their more affluent countrymen with portrait busts and statuary.

By the last quarter of the nineteenth century, American sculptors began to gravitate to Paris where they sought instruction at the Ecole des Beaux-Arts, the various academies, and the ateliers of prominent sculptors. Influenced by the academic tradition and the romantic, naturalistic French style, they worked in bronze and competed for international recognition in the then-prestigious annual Salons at the Grand Palais. Their work was for the most part well received at home and appealed to the taste and fashion of an era now referred to as the American Renaissance. During this period some American sculptors pursued their art without the benefit of foreign travel or formal instruction, while others studied at one of the long-established American art schools or at one of the newer schools, patterned after the French academies, that had been established in urban areas from coast to coast. The academic tradition was to dominate establishment art in the United States well into the twentieth century. However, Paris in the last decade of the nineteenth century offered alternatives to that tradition, and the

*Translated by Benita Eisler in Samuel Bing, *Artistic America, Tiffany Glass, and Art Nouveau* (Cambridge: the MIT Press, 1970), pp. 13-14.

venturesome young artists who studied there were exposed to influences that ranged from the work of the *animaliers* Antoine Barye and Emmanuel Frémiet to the revolutionary sculpture of Rodin and his circle.

In the early decades of the twentieth century, sculpture experienced profound changes. Although sculptors had lagged behind painters in the pursuit of new directions, meanings, and forms for artistic expression, a small but articulate number were experimenting with avant-garde concepts that were to challenge the very purposes of traditional sculpture. In the years preceding World War I, the influence of this group was to have an impact upon American sculpture. With the immigration of several of these artists to this country, the stage was set for the emergence of modern sculpture in America, but popular acceptance of their new concepts was not immediate. The sculptural activity that attended the rebuilding of San Francisco following the earthquake of 1906 and the Panama-Pacific International Exposition of 1915 perpetuated the traditional forms and functions of sculpture in this city for more than two decades. Although a few private collectors, such as Hélène Irwin Fagan, were to patronize contemporary modernists, the commitment of these museums to the exhibition of contemporary sculpture remained firmly tied to the increasingly conservative National Sculpture Society and culminated in the vast exhibition organized for the California Palace of the Legion of Honor in 1929.

As modernism came to dominate the art of the twentieth century, it became popular to discount the early American work in the craft tradition as "folk art" and to denounce as excessive, derivative, or academic the work of the nineteenth century, though all were essential to the development of the artists, patrons, and public who during the twentieth century were to sit in judgement upon American sculpture of the past and present.

The art of America's sculptors survives in the tons of marble, bronze, and carved wood that can be found in the squares, parks, battlefields, historic sites, and public buildings as well as the galleries, basements, and warehouses of museums throughout the country. The history of this art is preserved in the voluminous partisan, and not infrequently vitriolic, criticism engendered by the subject. In the past decade an increasing number of scholars, collectors, and institutions have directed their attention to this long-neglected material, and as William Gerdts observed in the foreword to his *American Neo-Classic Sculpture*, "with the advantages of hindsight and a hundred years of art history, we should be able to appreciate one art form without having to justify it by condemning another." In the presentation of this first exhibition of American sculpture from the collections of these museums, it is hoped that the perspective afforded by the late twentieth century will allow for a more objective acknowledgement of this important aspect of our artistic heritage.

Donald L. Stover
Curator in Charge
Department of Decorative Arts and Sculpture

Catalogue of the Exhibition

Dimensions are given in both inches and centimeters, height only unless otherwise designated. In the location of the marks, the proper right and proper left of the sculpture are abbreviated as PR and PL.

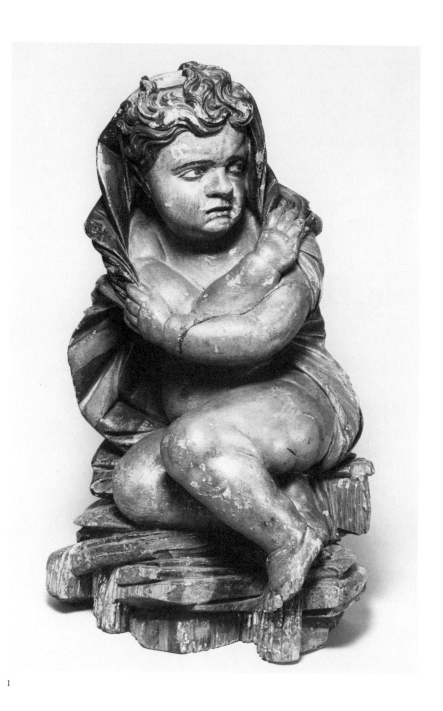

1

William Rush
1756–1833

William Rush was born in Philadelphia. The son of a ship's carpenter, he was apprenticed to Edward Cutburn, a woodcarver, and soon developed a reputation for his talent as a carver of ship decoration and figureheads. He established his own carving shop and, following service as an officer of the Philadelphia Militia in the American Revolution, developed a thriving trade. His work attracted international attention, and carvers in foreign ports sketched and made casts of some of his figureheads. Under the influence of his lifelong friend Charles Willson Peale and Joseph Wright, Rush emerged from the artisan tradition of wood-carver to become one of America's first native-born sculptors. As such he executed portrait busts in clay and terra-cotta, monumental wood figures of historical personages, and allegorical figures for civic projects and public and private buildings. A public-spirited citizen, he served as a member of the Philadelphia Common Council and, with Peale, was a founder and member of the Board of Directors of the Pennsylvania Academy of the Fine Arts.

1 **Figure of Winter**, ca 1825
Polychromed pine, 27 in (68.6 cm)
Art Trust Fund, 1981.7
Attributed to Rush or his studio, this figure bears a striking resemblance to allegorical figures depicting the four seasons found in continental and English ceramics of the eighteenth century, notably those produced by Chelsea in the 1750s and 1760s. Although the original provenance is unknown, it was probably created for an architectural context. Rush is known to have carved similar figures for George Carpenter's estate, Phil-Ellena, at Germantown, Pennsylvania, one of which was described in 1897 as being of a shivering figure of a youth seated on blocks of ice.

Hiram Powers
1805–1873

Powers was born near Woodstock, Vermont, and moved with his family to Cincinnati, Ohio. As a young man he became interested in sculpture, modeling figures in wax and executing portrait busts. Largely self-taught, he possessed a natural ability to produce likenesses, and his busts were realistically rendered without concern for sculptural style or convention. His talent impressed Nicholas Longworth who gave him encouragement, became his patron, and financed his move to Washington, D.C., in 1834. In Washington, Powers's ability as a portraitist served him well, and he received many commissions for busts of the political leaders and statesmen of the day. In 1837 Longworth sent him to Florence where he was to spend the remainder of his life. In Italy, Powers was exposed to the sculpture of antiquity and to the neoclassical work of the Italian followers of Canova and Thorwaldsen. These influences not only stimulated him to produce more ambitious, idealized sculpture but also informed the naturalism that had characterized his portraiture. The synthesis of these influences into Powers's style resulted in sculpture that epitomized the prevailing neoclassical movement and appealed to the popular taste of the period. The public and critical acclaim afforded his *Greek Slave* (1841–1845) when it was exhibited in the United States in 1847, and again at London's Crystal Palace in 1851, earned him an international reputation and made him the most famous American sculptor of his day.

2 **Bust of California**, ca 1858
Marble, 26¾ in (67.9 cm)
Gift of M. H. de Young, 42194

In 1850, inspired by the California gold rush and the success of his *Greek Slave*, Powers modeled a standing female nude which he called *El Dorado*. Retitled *California* and cut in marble in 1858, the full figure is now in the collection of the Metropolitan Museum of Art. This bust was the first of four known versions. It was originally purchased by Robert B. Woodward for the museum he was creating at Woodward's Gardens in San Francisco and was subsequently acquired by M.H. de Young, who presented it to this collection in 1916.

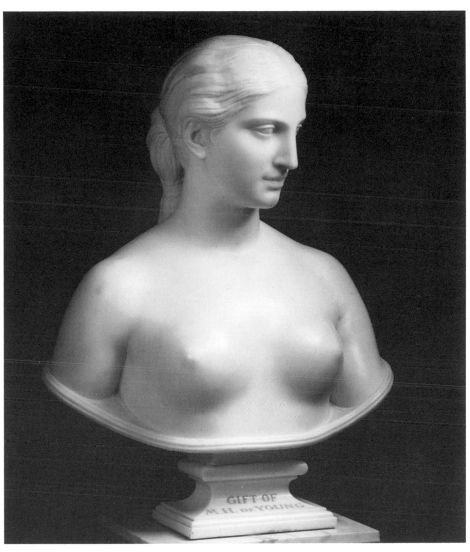

2

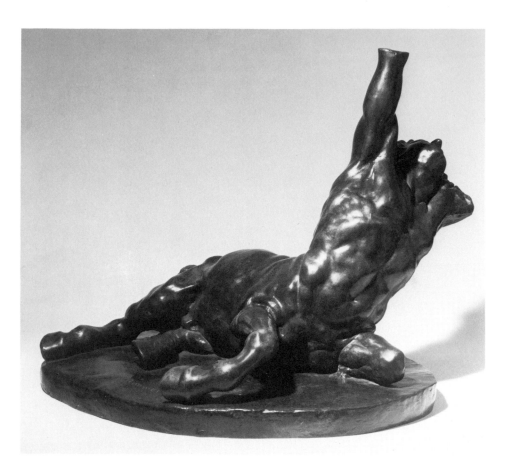

3

William Rimmer
1816–1879

Born in Liverpool, England, Rimmer was brought to America as a child when his parents settled in Boston. Although his early life was marked by poverty, he received instruction from his father in music, language, and the arts. Trained as a cobbler, he supported himself in that trade while pursuing self-instruction in medicine, painting, and sculpture. He was licensed as a physician in 1855. His knowledge of anatomy informed his art, particularly in sculpture, and by 1861 he was lecturing on art anatomy. In 1864 he published *The Elements of Design* and carved a granite statue of Alexander Hamilton for a monument in Boston. The former was the first of several educational texts that were to insure his fame as an author, lecturer, and educator. The latter, however, was a premature effort that so compromised the artist's reputation that he was to be denied the critical attention and commissions that his subsequent mature sculpture warranted.

Self-taught, he produced work that is free of the romantic neoclassicism that pervaded the ateliers of Rome and the academies of Paris. In its strength, vitality, and anatomical consciousness, Rimmer's work is more evocative of the Renaissance and the seminal work of the French sculptors Rude and Barye, and the few of his sculptures that survive are unique among American sculpture of their day. From 1866 to 1871 Rimmer directed the School of Design for Women at the Cooper Union in New York and lectured extensively in Boston, Worcester, and Providence, the National Academy of Design in New York, and the School of Fine Arts at Yale. His *Art Anatomy,* privately published by Harvard in 1877 and reprinted in several editions, was to influence American art and artists for a century after his death in 1879.

3 **The Dying Centaur**, ca 1871
Bronze, 21⅞ in (55.4 cm)
Markings: W. Rimmer (base front);
© by Kennedy Galleries Inc.
1967 #1/15 (PR base)
Gift of Mr. and Mrs. John D. Rockefeller 3rd,
1979.7.86
Considered the finest example of Rimmer's work extant, *The Dying Centaur* survived as a plaster model in the collection of the Museum of Fine Arts in Boston. A bronze in the collection of the Metropolitan Museum of Art was cast from this model in 1906. The Rockefeller bronze is no.1 of the fifteen cast by Joseph Ternbach in 1967 for the Kennedy Galleries from a plaster— probably the moulage made for the 1906 casting—now owned by the Yale University Art Gallery.

William Wetmore Story
1819–1895

Born in Salem, Massachusetts, William
Wetmore Story was the son of Joseph
Story, a distinguished Harvard law profes-
sor and an associate justice of the United
States Supreme Court. He graduated from
the Harvard Law School in 1840 and, in
addition to practicing law, wrote and pub-
lished extensively on the subject. A privi-
leged and cultivated young man, he also
pursued his interests in literature, poetry,
music, and modeling sculpture. After his
father's death in 1845 he was offered the
commission for a proposed monument
and, although he had no formal training
in sculpture, accepted the challenge. For
seven years he worked on the project, di-
viding his time between his law practice
in Boston and study and work in Rome,
where in 1853 the statue of Justice Story
was finally cut in marble.

In 1856 he gave up law for sculpture and
settled permanently in Rome. His apart-
ment in the Palazzo Barberini became a
gathering place for an artistic and literary
group that included Robert and Elizabeth
Browning, Nathaniel Hawthorne, William
Thackeray, Henry James, and fellow
sculptor Thomas Crawford. As he was fi-
nancially independent, Story did not have
to depend on portrait commissions for his
livelihood, and the bulk of his work con-
sists of large figures derived from litera-
ture, history, and mythology. His *Cleopatra*
(1858) and *Libyan Sibyl* (1861) earned him
international recognition, and for the next
decade he produced a series of heroic fig-
ures, including *King Saul* (1863), *Medea*
(1864), *Dalilah* (1866), and *Salome* (1870).
Although Story was influenced by an-
tiquity and the neoclassical tradition of
Rome, his work is characterized by its
literary allusions, and his figures are more
apt to portray the subjects didactically
than to embody their spirit in sculptural
form. Criticized in his own time for this
literary romanticism, he was nonetheless
one of the most famous American
sculptors of his day. Among the last of his
works was the imposing *Francis Scott Key
Monument* modeled in 1886 and erected in
San Francisco's Golden Gate Park. He died
in Rome in 1895.

4 Dalilah, 1877
Marble, 76 in (193 cm)
Markings: W W (monogram) Story.
Roma. 1877. (PL base); Dalilah (base
front)
Gift of M. H. de Young, 49621
Story drew from the Old Testament for
this monumental figure of the woman
from the Valley of Sorek whose treachery
delivered Samson into the hands of the
Philistines. The figure of *Dalilah* is
portrayed brooding over the accomplished
act. As is typical of the sculptor's didactic
literalism, he leaves no doubt about her
identity: in her left hand she clutches the
"shekels of silver" in a Victorian coin
purse, and at her feet lie a nineteenth-
century straight razor and the seven locks
of Samson's hair. Cut in marble in 1877
after the original version of 1866, the
Dalilah, along with Story's *King Saul,* was
acquired in Rome by Mrs. Theodore Shil-
labar. Both were installed in the statue
room of her mansion on Mission Street in
San Francisco. They were subsequently
acquired by M.H.de Young for the
museum.

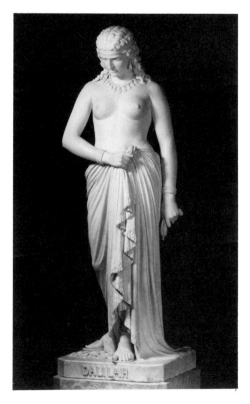

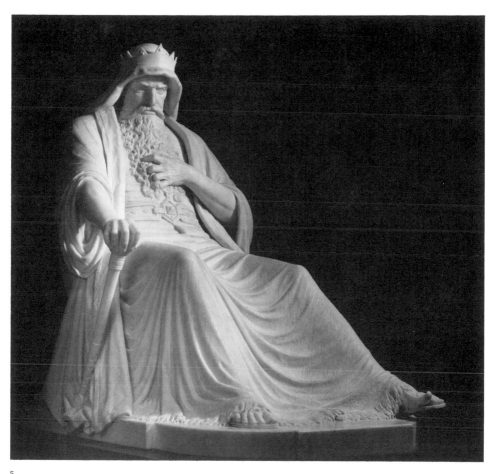

5

5 **King Saul**, 1882
Marble, 57 in (144.8 cm)
Markings: WWStory (monogram); Roma
1882 (base rear)
Gift of M. H. de Young, 49622
Noting that he considered it his finest
work, Story completed the first version of
King Saul in 1863. In biblical history Saul
was the son of Kish of the Tribe of Benja-
min and was chosen first king of Israel
around 1025 B.C. Story has represented
his subject at a moment when, as de-
scribed in I Samuel 16:14, "the spirit of the
Lord departed from Saul and an evil spirit
from the Lord tormented him." In a sec-
ond version modeled in 1882, a great staff
was substituted for a knife in the right
hand. Two copies, of which this is one,
were cut in marble that year. The gesture
of the left hand at the beard is reminiscent
of that of Michelangelo's *Moses*.

Pietro Mezzara
1820–1883

Although of Italian ancestry, Pietro Mezzara was born in France where he worked as a carver of cameos before becoming a sculptor. He immigrated to the United States in the early 1850s and by 1858 had settled in San Francisco. A relief portrait of President James Buchanan brought him local recognition, and a portrait bust of Senator D.C. Broderick, a popular political figure who was killed in a duel with a pro-Southern Civil War advocate, increased his reputation.

Although much of his work consisted of portrait commissions, he modeled a figure of Charity for the San Francisco Masonic Temple, a figural group of Romulus and Remus for the Mechanic's Pavilion at the Mechanic's Institute Fair, and allegorical figures of California, Education, Industry, Justice, Law, and Mining for the State Capitol building at Sacramento. His most famous work was a monumental plaster statue of Abraham Lincoln which he modeled in 1865 and exhibited at the Second Mechanic's Institute Fair. The plaster, described as "majestic and commanding," was placed at San Francisco's Lincoln School. Cast in bronze in 1889, the statue was destroyed in the 1906 earthquake. Mezzara was a member, director, and officer of the San Francisco Art Association and served on the committee that founded the association's California School of Design. In the latter capacity he was in charge of selecting and acquiring the plaster casts of classical sculpture that were deemed necessary for the school's art instruction. He served on the standing committee for the school from its opening in 1874 until 1880 when he returned to Paris where he died three years later.

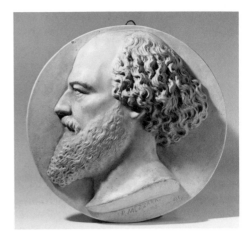

6

6 Relief Portrait of Justice Stephen J. Field, 1868
Plaster, diameter 16 in (40.6 cm)
Markings: P. Mezzara / San Francisco 1868 (below neck)
Ref. no. X1982.11

Born in Haddam, Connecticut, in 1816, Stephen J. Field came to California in 1849. A distinguished jurist, he was a judge of the United States Circuit Court, served as the chief justice of the California Supreme Court from 1859 to 1863, and was an associate justice of the United States Supreme Court from 1863 until 1897. He died in Washington, D.C., in 1899.

7 Bust of George Gordon, 1869
Painted plaster, 24 in (62 cm)
Markings: Mezzara 1869 (PL base)
Gift of John T. Doyle, 40849

George Gordon was born in London, immigrated to the United States, and settled in San Francisco where he made a fortune in a variety of enterprises that included the lumber business, wharf construction, an iron foundry, and a sugar refinery. As a pioneer real estate developer he created South Park, an elegant neighborhood on San Francisco's Rincon Hill that preceded Nob Hill as the city's most fashionable address. His Palo Alto estate, Mayfield Grange, was later acquired by Leland Stanford and is now part of Stanford University.

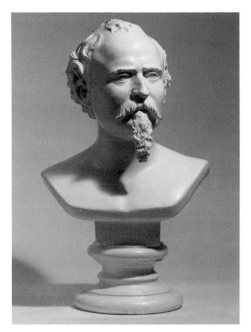

7

Randolph Rogers
1825–1892

Born in Waterloo, New York, Rogers spent
his childhood in Ann Arbor, Michigan. As
a young man he sought employment in
New York City where he became in-
terested in the arts. By 1848 his early ef-
forts at drawing and modeling portraits
showed sufficient talent to secure him pa-
tronage for study abroad. Following work
with Bartolini in Florence, he settled in
Rome. Strongly influenced by the ancient
monuments and the romantic neoclassi-
cism of his day, Rogers's work received
popular acclaim. The success of his *Nydia*
(1853) not only provided him recognition
but also secured important patronage, in-
cluding the 1855 commission for the great
bronze doors for the rotunda of the
Capitol in Washington. In this monumen-
tal work, Rogers translated the biblical im-
agery of Ghiberti's masterful baptistry
doors at Florence to the historical imagery
of Columbus's discovery of America. Fol-
lowing the death of Thomas Crawford in
1857, Rogers was selected to complete
other commissions for the Capitol and
Crawford's important but unfinished
Washington Monument in Richmond,
Virginia. He retired in 1882 and died in
Rome in 1892.

8 **Bust of Milton S. Latham**, ca 1860
Marble, 26 in (66 cm)
Markings: Randolph Rogers / Rome.
(base rear)
Gift of Mrs. Milton S. Latham, 45147
Milton Slocum Latham was born in Co-
lumbus, Ohio, in 1827 and graduated from
Jefferson College in 1845. He settled in
California where he was admitted to the
bar in 1848. In addition to practicing law,
he held positions as clerk of the Recorder's
Court in San Francisco and district attor-
ney of Sacramento County. He was elected
to the United States House of Represen-
tatives for the Thirty-third Congress
(1853–1855) and was elected governor of
California in 1859. He resigned the latter
office after only six days to take a seat in
the United States Senate (1860–1863).
Latham returned to San Francisco where
he was involved in banking, and from
1880 until his death in 1882 he served as
president of the New York Mining and
Stock Exchange.

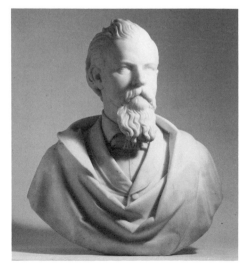

8

Herbert Gleason
working 1871–1878

In 1871 Herbert Gleason became the principal of McIntyre and Gleason, a respected Boston ship-carving firm, originally established in 1847 as S.W. Gleason and Sons. During the years of his proprietorship, Herbert Gleason provided figureheads and carvings for some of the finest sailing vessels built in Boston. In this effort he was assisted by Joseph Doherty and by Warren Hastings, who became a partner of the firm in 1878 and continued its operation until his death. The half century in which this firm of distinguished woodcarvers operated witnessed the zenith of the artisan tradition of American ship carving; however, that tradition was rapidly nearing extinction when the shop closed its doors in 1896.

9 Figurehead from the Ship *Centennial*, ca 1875
Wood, painted white, 86½ in (219.7 cm)
Ref. no. X1971.336
The symbolic or allegorical carvings for the prows of sailing vessels represented the highest expression of the ship-carver's art, and the forward-striding full figures carved for the sleek-hulled nineteenth-century clipper ships are the finest extant examples of that art. This splendid figure, which originally graced the prow of the *Centennial,* reveals Gleason's mastery of his craft and his ability as a sculptor to convey something of the spirit of these great ships and the pride of a nation celebrating the 100th anniversary of its independence.

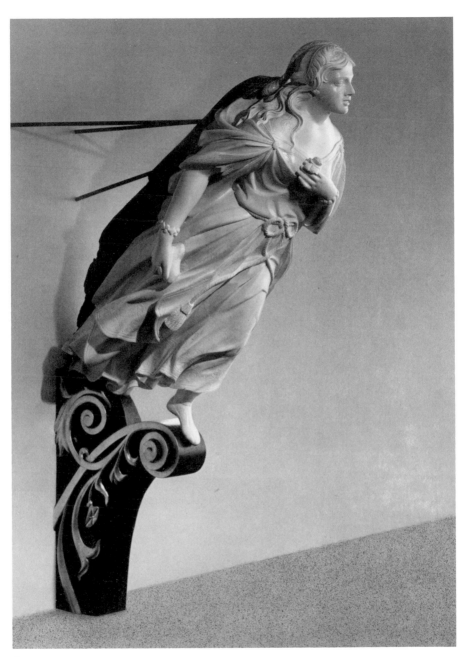

9

James Henry Haseltine
1833–1907

James Henry Haseltine was born in Philadelphia to a large, prosperous, and art-conscious family. His mother sat for Thomas Sully, his brother William Stanley was to become a painter, and his brother Charles Field founded the Haseltine Art Galleries. James chose to be a sculptor, and after study with Joseph Bailly at the Pennsylvania Academy of the Fine Arts he traveled and studied in Paris and Rome. He returned to the United States in 1861 for service in the Union Army and resumed his study in Europe in 1863. Although he spent most of his life in Rome, much of his work was sent back to America, where his classically inspired marble portraits and allegorical sculpture attracted the attention of the critics of his day.

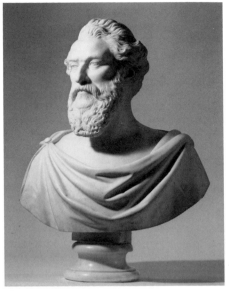

10

10 **Bust of Mr. Frank M. Pixley**, 1871
Marble, 30¼ in (76.8 cm)
Markings: J.H. Haseltine / Rome. 1871.
(back)
Gift of Miss Vera Pixley, 42625
Frank M. Pixley came to California as a forty-niner and achieved considerable stature as a brilliant, eloquent, and controversial politician, legislator, and publisher of a political and literary journal entitled *The Argonaut.* He was a staunch Republican who opposed slavery and steadfastly defended the public interest against political corruption. Outspoken in his class antipathies and a defender of the railroad interests, he was as much despised as admired. At his death in 1893, his obituary described him as essentially and necessarily a partisan—as one-sided as he was brilliant and bold. In the style typical of the neoclassical tradition of the School of Rome, Haseltine sculpted Pixley draped in a toga as a Roman statesman.

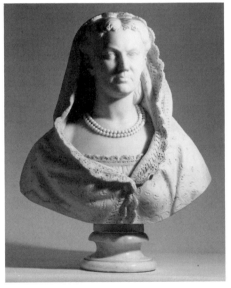

11

11 **Bust of Mrs. Frank M. Pixley**, 1871
Marble, 29¼ in (74.3 cm)
Markings: J.H. Haseltine./Rome 1871.
(back)
Gift of Miss Vera Pixley, 42624
Haseltine has depicted Mrs. Pixley in contemporary attire. The detail and texture of her lace dress and mantle are a tour de force of stone carving and display the skill of the nineteenth-century Roman marble carvers.

Franklin Simmons
1839–1913

Born in Webster, Maine, Franklin Simmons spent his childhood in Maine, but his interest in modeling in clay led him to Boston. There he saw collections of plaster casts of antique sculpture, studied the public sculpture, and worked briefly in the studio of John Adams Jackson. Returning to Maine, he eventually settled in Portland, where his training in Boston enabled him to obtain commissions for portrait busts of local patrons. A favorable reaction to his portraiture prompted him to move to Washington, D.C., where in the years following the Civil War he enjoyed considerable success sculpting busts of political leaders, war heroes, and historical figures.

In 1867 Simmons went to Italy and settled in Rome. Like other American sculptors who had come there, he began to create ideal figures; however, his work was deeply grounded in the naturalistic tradition of his homeland and avoided the romanticism that marked that of many of his contemporaries. His sculpture in the neoclassical tradition is considered among the finest produced by an American of the period.

Unlike many of his colleagues, Simmons maintained close touch with America, and in the numerous portraits, statues, and monuments that he produced for her cities in the 1880s and 1890s his mature style manifested itself. In these works, such as his monument to the Union in Portland, Maine, and *General Logan* in Washington, Simmons subjugated detail to composition and pretention to honesty of presentation. In so doing he achieved an expressive freedom and a grandeur of sculptural form. Not only was his success rewarded financially, but he was knighted by King Humbert of Italy in 1900. He died in Rome in 1913.

12 Bust of General William Tecumseh Sherman, ca 1866
Marble, 21¾ in (55.2 cm)
Markings: F. Simmons (base rear)
Gift of George Crocker, 8837

This bust of Sherman, from the series of busts of Civil War heroes sculpted in 1865 and 1866, is considered one of Simmons's finest portraits. Sherman was a graduate of West Point but resigned his commission in 1853 to enter the banking business in San Francisco. He returned to active military duty in 1861. Promoted to the rank of brigadier general, he distinguished himself in the Union cause. He survived the harsh criticism leveled at him for his infamous march to the sea and was ultimately named commanding general of the army in 1869.

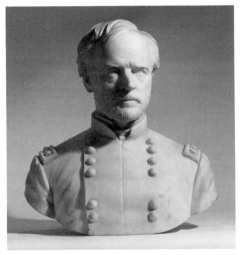

12

Thomas Eakins
1844–1916

Better known as a painter, Thomas Eakins had a lifelong interest in sculpture and produced a small but significant group of works in that medium. The son of a calligrapher and writing master, he was born and educated in Philadelphia. After considering a career in medicine, he chose to become an artist and enrolled in classes at the Pennsylvania Academy of the Fine Arts and studied anatomy at Jefferson Medical College. Encouraged by his father, he went to Paris where he studied painting with Jean-Léon Gérôme and Léon Bonnat and took instruction in modeling with the sculptor Augustine-Alexandre Dumont.

Returning to Philadelphia in 1870, he established himself as a painter and resumed his anatomical studies at Jefferson Medical College. In 1879 he was appointed Professor of Drawing and Painting at the Pennsylvania Academy, and from 1882 until his resignation in 1886 he served as director of the Academy's school.

During this period he became fascinated with photography and relief sculpture. Although most of his efforts in these media have been considered studies for paintings, he submitted two small reliefs for exhibition in 1884. In 1891 Eakins executed a group of life-size horses for the Memorial Arch in Brooklyn's Prospect Park and the following year was awarded the commission for the monumental bronze reliefs for the Trenton Battle Monument. Also in 1892 he began to share his studio with Samuel Murray, a sculptor whose career he attempted to promote. In the years that followed, Eakins and Murray collaborated on several sculpture commissions, including the 1906 statue of Commodore Barry now in Independence Square. His productive career was ended in 1911 by poor health and failing eyesight, and he died at Philadelphia in 1916.

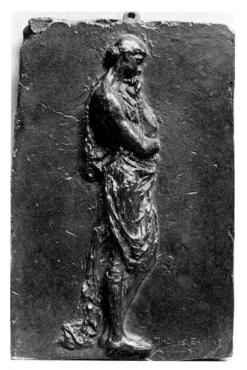

13

13 An Arcadian, 1883
Bronze relief, cast 1900–30, 8¼ in (21 cm)
Markings: Thomas Eakins (lower right);
Roman Bronze Works, N.Y. (lower left)
Gift of Mr. and Mrs. John D. Rockefeller 3rd,
1979.7.36

Thought to be a unique casting in bronze, this relief depicts a single figure from a larger relief entitled *Arcadia,* produced in 1883 when Eakins was exploring bucolic themes in his photography, painting, and relief sculpture. *Arcadia* is the most successful of these exercises, and although there is no evidence that it was ever exhibited, Eakins included it in the background of his first portrait of his wife.

C.S. Newell
working 1886–1889

One of the two identical plaster reliefs of
Virgil Williams in the collection of these
museums is signed by C.S. Newell. How-
ever, little information has been found to
date on the artist who modeled this splen-
did little portrait. The 1922 entry in the
accession records of the M.H. de Young
Memorial Museum for the unsigned ver-
sion simply notes that it was "made by
one of his students (Mr. Newell)." It has
traditionally been assumed that he studied
with Williams at the California School of
Design. Regrettably, the records of the
school, which moved into the Mark Hop-
kins house on Nob Hill, were lost in the
fire that destroyed the mansion following
the earthquake of 1906. The skill and sen-
sitivity with which the difficult medium of
relief portraiture has been handled implies
either an exceptionally gifted student or
an experienced and well-trained hand.
The San Francisco city directories for 1886
through 1889 list a C.S. Newell working as
a sculptor, first in partnership with Albert
Weinert at 802 Montgomery Street and on
his own by 1888.

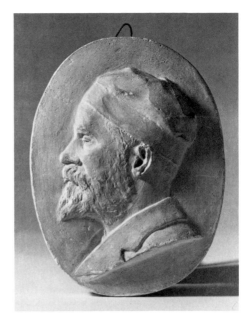

14

14 **Relief Portrait of Virgil Williams**,
ca 1886
Plaster, 8½ in (21.6 cm)
Markings: C.S. Newell / 802 Montg /
COMP / J.R.M. (back)
Gift of Mrs. Robert Rembrandt Hill, S49.3
An important influence upon the devel-
opment of art and culture in San Francisco
in the last quarter of the nineteenth cen-
tury, Virgil Williams was born in Maine
and grew up in Massachusetts. He studied
painting at the National Academy of De-
sign before going to Europe in 1856. There
he married the daughter of the American
painter William Page, with whom he had
studied, and stayed to live and work in
Rome, Naples, and Florence. His first con-
tact with San Francisco was a commission
to paint copies of old masters for the art
gallery at Woodward's Gardens, and he
visited the city before returning to Boston
where he taught drawing at Harvard. He
moved to San Francisco in 1871 and be-
came part of a growing colony of artists
that included, among others, Albert
Bierstadt, Thomas Hill, William Keith,
and Pietro Mezzara. He was one of the
organizers and later president of the Bo-
hemian Club and was a charter member
of the San Francisco Art Association.
When the latter founded the California
School of Design in 1874, Williams was
appointed director and instructor and
held both positions until his death
in 1886.

Jonathan Scott Hartley
1845–1912

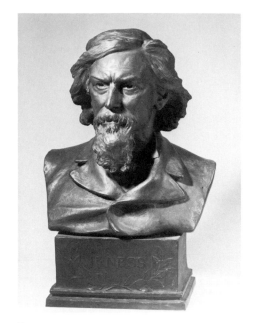

Born in Albany, New York, Jonathan Scott
Hartley was educated at the Albany
Academy and began his study of sculpture
in the studio of Erastus Dow Palmer.
Palmer, whose work was deeply grounded
in the American naturalistic tradition, was
one of the best-known sculptors of the
period in this country; however, he was
self-taught, and it is doubtful that he
provided his young pupil with much for-
mal instruction. Hartley left Albany and
pursued his study in New England, Italy,
and Paris. He settled in New York where
he established a studio and began execut-
ing portrait busts, portrait statues, and
public monuments, among them the
Daguerre Monument in Washington,
D.C.; the Ericson Monument in New York
City; and a statue of Miles Morgan in
Springfield, Massachusetts. He served as
president of the Art Students' League of
New York from 1878 to 1880, and in 1888
he married the daughter of the American
landscape painter George Inness. He was
made a member of the National Academy
of Design in 1901 and died in New York
in 1912.

15

15 **Bust of George Inness**, 1894
Bronze, 24 in (61 cm)
Marking: Inness (base front); Hartley,
Sc./1894 (PL base); Roman Bronze Works
N.Y. (PR base side)
*Dr. T. Edward and Tullah Hanley Memorial
Collection*, 69.30.95
Considered one of the finest American
landscape painters of the nineteenth cen-
tury, George Inness was born in Newburg,
New York, in 1825. Although he had some
instruction in drawing and studied for a
time with Regis Gignoux, he was largely
self-taught. He was elected to the National
Academy of Design in 1853, and his works
were exhibited widely both in the United
States and abroad. Inness traveled exten-
sively and worked in France and Italy. This
bust, modeled by his son-in-law, dates
from the time of his death in 1894.

Samuel Anderson Robb
1851–1928

Samuel Anderson Robb, son of a Scottish
immigrant shipwright, was born in New
York City and apprenticed to Thomas
Brooks, a ship-carver. Robb exhibited a
talent for both drawing and carving, and
after five years in the Brooks shop he was
hired to carve figures for William Demuth,
an importer and manufacturer of pipes
who also carried shop signs and figures for
the tobacconist trade. By tradition, such
carving was considered inferior to that of
the ship-carver. However, Demuth pro-
posed to elevate the quality and status of
the craft. He encouraged his young carver
to further his study of art, and in 1869
Robb was accepted into the Free Night
School of Science and Art in the Cooper
Union and studied at the National
Academy of Design until 1873. During this
period Robb supplied carved wooden fig-
ures, models to be cast in zinc, and other
carvings for Demuth, whose business was
to become the largest of its kind in the
world, with over 1,000 workmen and
showrooms in New York, Chicago, and
San Francisco.

In 1876 Robb established his own shop
at 195 Canal Street. William Demuth
remained the shop's principal client
and patron; Robb provided carvings
for his former employer's showrooms
and carved decoration and figures for
Demuth's yacht, *Geneva*. The new shop
retailed trade figures and shop signs,
executed religious figures and groups
for churches, and carved circus wagons.
Although William Demuth and Samuel
Robb were to succeed in raising the artistic
quality and standards of the trade-figure
and shop-sign carver's craft, their success
was to preclude Samuel Robb's transition
from artisan wood-carver to sculptor.

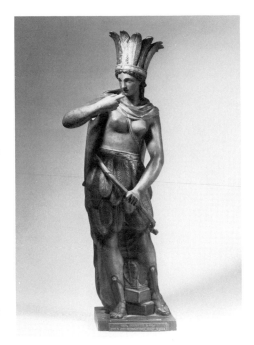

16

16 **Indian Maiden**, ca 1875
Painted zinc, 34 in (86.4 cm)
Markings: Wm. Demuth & Co / 507 & 509
Broadway, New York (base front)
Ref. no. X1982.9

In 1868 William Demuth contracted with
Morris Seelig, a zinc founder, to produce
metal casts of some of his carved wooden
figures. The first of these painted zinc fig-
ures were exhibited in New York 1869 and
were awarded the medal of the American
Institute of the City of New York. Within a
few years the sale of the metal figures was
to far exceed that of the wooden ones. The
Indian Maiden was copyrighted in 1875
while Samuel Robb was supplying him
with carved wooden models and figures
and was illustrated in Demuth's catalogue
under metal figures no. 66a and no. 66b.
The two figures illustrated differ only in
height and design of their pedestals and
were priced at $28.00 and $26.00.

Clement J. Barnhorn
1857–1935

Born in Cincinnati, Ohio, Barnhorn was
graduated from St. Xavier University and
in 1880 enrolled at the Cincinnati Art
Academy. He studied modeling under
Louis T. Rebisso and subsequently worked
in his studio, assisting on the commissions
for the Grant Monument for Chicago's
Grant Park and the Harrison Monument
for Cincinnati. Barnhorn also studied and
worked as a wood-carver in the studio of
Henry Fry, and in 1890 he collaborated
with his friend Frank Duveneck on the
monument for the tomb of Duveneck's
wife.
In 1891 the Art Academy awarded Barn-
horn a scholarship for study in Europe.
After travel in Italy, he settled in Paris and
studied sculpture with Mercié, Puech, and
Frémiet. He also took instruction in draw-
ing with Bouguereau. His experience in
Paris aided in the development of his per-
sonal style; he was little influenced by
Rodin and his followers. He exhibited
regularly at the salons, and his *Magdalen*
received honorable mention in 1895.
During the five years Barnhorn remained
in Paris, Duveneck was a frequent visitor,
and upon Barnhorn's return to America
he occupied a studio adjacent to
Duveneck's at the Cincinnati Art
Museum. There he worked in wood,
bronze, and stone as well as modeled fig-
ures that were executed in Rookwood
faience. With the death of Rebisso in 1901,
Barnhorn was appointed to the faculty of
the Art Academy, a position he held until
his death.

17

17 **Boy Pan with Frog**, 1914
Bronze, 48 in (121.9 cm)
Markings: Clement J. Barnhorn
© 1914 Roman Bronze Works NY (base,
circling feet)
Gift of Walter Scott Newhall, 65.27
Modeled from life in 1913, this fountain
group was created for the Clara Bauer
Memorial at the Cincinnati Art Museum
in 1914 and was included in their retro-
spective exhibition of Barnhorn's work
in 1934.

Frederic Remington
1861–1909

Frederic Remington was born at Canton, New York, but grew up in nearby Ogdensburg. He attended Yale University where he received some instruction in art and published some of his sketches. His academic study was brief, however, and in 1880 he began a period of extended travel through the western United States. He tried his hand at prospecting, worked as a cowboy and ranch hand, participated in Indian wars and skirmishes, and chronicled his experiences in a portfolio of skillfully drawn sketches. In 1886 he returned to New York, settled at New Rochelle, and, drawing upon his firsthand observations and his sketches, became a successful illustrator for books and articles on the American West, including Theodore Roosevelt's *Ranch Life and the Hunting Trail.*
Following study at the Art Students' League, Remington began to paint in oils and, encouraged by the sculptor Frederick Ruckstull, experimented with modeling small figures. *The Bronco Buster,* cast in 1895, was the first of a series of forcefully modeled small figures of men and horses which in their attention to detail, characterization, and suspended action reflect his talent and experience as an illustrator. These bronzes, like his illustrations and paintings, were widely acclaimed and were well subscribed to by a public fascinated with the West and life on what was perceived as the rapidly vanishing American frontier. In the decade of the 1890s he traveled in Russia, Germany, and North Africa and was in Cuba during the Spanish-American War. Remington was a charter member of the American Institute of Arts and Letters and was elected an associate of the National Academy of Design. He died at Ridgefield, Connecticut, in 1909.

18 The Bronco Buster, 1895
Bronze, 24 in (61 cm)
Markings: 56 Frederic Remington (PR base); Copyrighted by / Frederic Remington. 1895 (base rear); By The Henry Bonnard Bronze Co. Founders N.Y. 1899 (PL base)
Gift of Doris Schmiedell and The de Young Museum Foundation, 69.21
The Bronco Buster was Remington's first sculpture to be cast in bronze and was his most popular work in that medium. Without any background in sculptural composition or convention, the artist has combined in this bronze a natural affinity for modeling with his illustrator's eye and familiarity with the subject to produce a work that possesses both sculptural and literal validity. This work, dated 1895, is no. 56 of the original edition of seventy cast in New York by the Henry Bonnard foundry.

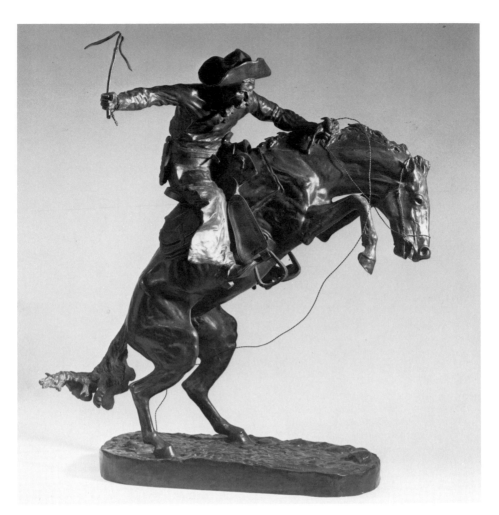

18

Frederick William MacMonnies
1863–1937

Born in Brooklyn, MacMonnies became interested in sculpture as a child, first modeling in wax and later carving in stone. In 1880 he began working at odd jobs in the studio of Augustus Saint-Gaudens, who recognized his talent and took him as an assistant and pupil. Encouraged by Saint-Gaudens, he enrolled in drawing classes at the National Academy of Design and the Art Students' League. In 1884 he left the studio for travel and study abroad. He was admittted to the Ecole des Beaux-Arts where he studied sculpture with Falguière. Although he left Paris for a brief interval to study painting in Munich and returned to New York for a year to assist Saint-Gaudens on several commissions, his work at the Ecole was twice awarded the prestigious Prix d'Atelier.

Upon completion of his study at the Ecole, MacMonnies became an assistant to Falguière before setting up his own studio in Paris. His bronze *Diana,* exhibited at the Salon of 1889, was awarded an honorable mention, and its critical acclaim earned him an international reputation. Two years later he became the first American sculptor to receive a Medal of the Second Class at the Salon. These successes assured MacMonnies numerous commissions, including one for the most important sculpture group for the World's Columbian Exhibition in Chicago in 1893. Variously entitled *The Triumph of Columbia* or *The Barge of State,* this monumental composition established his fame in America; and, although his *Bacchante and Infant Faun* of the same year aroused considerable controversy, he was acknowledged as one of the most prominent American sculptors of the decade.

In its rejection of neoclassicism, its rich modeling and vital naturalism, MacMonnies's work compared favorably with the finest foreign sculpture of the day, and in 1900 he received a grand prize at the Paris Exposition. His later work became increasingly influenced by Rodin; however, it was to lack the spontaneity and invention that characterized his best sculpture of the 1880s and 1890s. In 1905 he established a studio school at Giverny, but in 1915

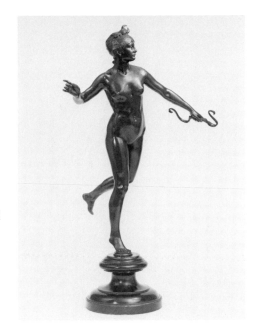

19

he returned to America where for the remainder of his life he discouraged sculpture commissions and occupied himself with painting.

19 **Diana**, 1889
Bronze, 29 in (73.7 cm)
William H. Noble Bequest Fund, 1981.15
Modeled while MacMonnies was working in the Paris studio of Jean Alexandre Falguière whose interest in the female figure surely influenced MacMonnies's choice of the subject, *Diana* clearly evinces the sculptor's rejection of the neoclassical style. Identified by her traditional symbols, the bow and the crescent in her hair, MacMonnies's *Diana* is not a classical ideal of the goddess but rather a sensitively modeled study of the form and flesh of a real woman, sensual, confident, and accustomed to movement.

Charles Marion Russell
1864–1926

The son of a prosperous St. Louis brick manufacturer, Charles Marion Russell was born at Oak Hill, Missouri. As a child he exhibited an artist's inclination and a rebellious personality, and at the age of sixteen he left home to seek the freedom and adventure of the frontier. During his travels he worked as a fur trapper and cowboy, became conversant with most of the Plains Indians tribes, and lived for a season among the Blackfoot Indians. He recorded his travels and experiences in sketches, drawings, and watercolors and began to paint in oils.

By 1893 Russell had settled in Montana, and following his marriage to Nancy Cooper in 1896 he set up a studio in Great Falls. National recognition of his talent was slow, but his wife exerted a positive influence upon his career, encouraging him to expand the exposure of his work and accompanying him on trips to New York in 1903, 1904, and 1905. There his paintings and watercolors were well received by collectors and the public who were by then familiar with the western subjects of Frederic Remington. While in New York, Russell secured commissions for illustrations and became interested in modeling.

His first bronze, *Smoking Up,* was cast by the Co-operative Society at the Roman Bronze Works. This was the first of over 300 sculptures that he was to execute, of which approximately fifty were cast in bronze during his lifetime. These bronzes possess a naturalism and vitality similar to that seen in the bronzes by Remington, but they are less literal and more evocative in the characterization of the subject matter.

Russell died in Great Falls, Montana, in 1926.

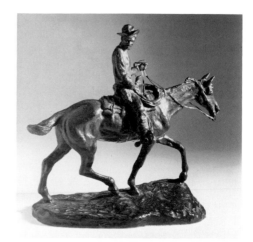

20

20 **Will Rogers on Horseback**, ca 1911
Bronze, 11¼ in (28.6 cm)
Markings: CM Russell / Art Bronze Calif L.A. (base)
Gift of Walter Selby McCreery, 1963.21
Charles Russell became acquainted with Will Rogers, the American actor, humorist, humanist, and rope-twirling "poet laureate" of his era, in a chance meeting on a train, and the two became lifelong friends. In this bronze, Russell has depicted his friend dressed and outfitted as a working cowboy astride a horse. It is probably not coincidental that a strikingly similar bronze entitled *The Horse Wrangler,* differing slightly in the pose of the figure and stance of the horse, is thought to be a self-portrait of the artist.

Rupert Schmid
1864–1932

The son of a stone carver, Rupert Schmid was born in Munich in 1864 and was reputed to have been a promising sculptor before his immigration to the United States in 1884. He settled first in New York where he showed a bust of Dr. Howard Crosby at the 1885 annual exhibition of the National Academy of Design. By 1890 he was living and working in San Francisco. Although the majority of his commissions were for portrait busts, he also executed full figures and figural groups and supplied architectural carving, including the sculptural decoration for the Chronicle and Spreckels buildings. In 1892 he won a national competition that awarded a $25,000 commission for a Milwaukee monument to German-Americans. The following year he modeled a female figure to represent California women for the World's Columbian Exposition. This figure brought him local fame, and, although it was not conceived as a classical ideal but rather an attempt to represent realistically the physical proportion and beauty of the feminine form of the nineteenth century, it came to be known popularly as the "California Venus" when the plaster cast and later the marble version were exhibited in San Francisco. As a result of his association with M. H. de Young, he produced a portrait bust of the art patron and also provided the "California Fountain" for the California Midwinter International Exposition in 1894.

In 1906 much of his work and his quaint home and studio—carved and painted in the manner of his homeland—were destroyed in the earthquake and fire. For the next seven years Schmid traveled extensively, working for various periods in Washington, D.C., Germany, Italy, and Mexico. He returned to San Francisco in 1913 to execute commissions for the Panama Pacific International Exposition for which he provided architectural decoration and the colossal figure *Queen of the Pacific.* He died in Alameda, California.

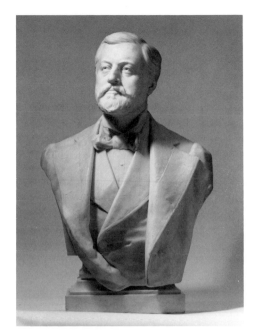

21

21 **Bust of William Franklin Herrin,** 1898
Marble, 33½ in (85.1 cm)
Markings: R. Schmid, Sc. / 1898 (above base rear)
Gift of the Estate of William F. Herrin, 53761
William Franklin Herrin, born in Jacksonville, Oregon, in 1854, received his law degree from Cumberland University in 1875. He practiced law in San Francisco where he married the daughter of Judge Peter Van Clief. He joined the powerful Southern Pacific Company and was appointed chief counsel in 1893 and named vice president in 1910. He died in San Francisco in 1927.

Paul Wayland Bartlett
1865–1925

Paul Wayland Bartlett was born at New Haven, Connecticut, the son of Truman H. Bartlett, who was a sculptor, teacher, critic, and the biographer of William Rimmer. At the age of nine, he was sent to Paris for an education in the arts, which his father felt he could not obtain in the United States. Five years later he exhibited a portrait bust at the Paris Salon of 1879, and the following year he entered the Ecole des Beaux-Arts where he studied with Pierre Jules Cavelier. He was strongly influenced by the French *animaliers,* notably Emmanuel Frémiet, with whom he studied, and Georges Gardet, in whose studio he worked. Bartlett's work had begun to attract critical attention at the Paris Salons, and he was made a chevalier of the Legion of Honor in 1895. His reputation in America was established by the monumental figures of Columbus and Michelangelo that he sculpted for the rotunda of the Library of Congress in 1898. The following year he received the commission for an equestrian monument to Lafayette for the Place du Carrousel at the Louvre. In 1909 he was awarded the prestigious commission for the sculpture of the long-empty pediment of the House of Representatives' wing of the United States Capitol and, in 1910, the commission for the monumental allegorical figures for the facade of the New York Public Library. He was elected to the National Academy of Design in 1917 and became president of the National Sculpture Society in 1918. He died in Paris in 1925.

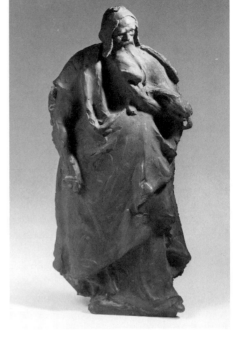

22

22 **Philosophy**, 1910
Bronze, cast 1927, 16 in (40.6 cm)
Markings: 1927 © B / PW Bartlett
(PR edge)
Gift of Mrs. Armistead Peter III, 1959.22
This bronze is a casting from a maquette of one of the six monumental figures executed for the facade of the New York Public Library. Although the designs were approved in 1910, the marble figures (which measured 10½ feet in height) were not completed until 1915.

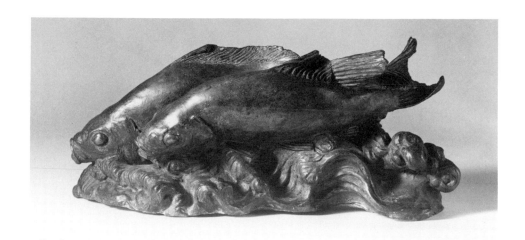

23

23　Two Fish (Sculpin)
Bronze, 4⅝ in (11.7 cm)
Markings: PWB SF (within drawn
rectangle) 3 (PR rear)
Gift of Mrs. Armistead Peter III, 1959.21
This or a similar bronze was exhibited by
Bartlett at the National Sculpture Society
in 1923 under the title *Sculpin.* Sculpin are
large-headed, broad-mouthed, usually
scaleless fish of the family Cottidae.

Orazio (Horatio) Piccirilli
1872–1954

In March of 1888 Ferruccio Piccirilli, eldest son of Guiseppe Piccirilli of Massa-Carrara, Italy, and a descendant of generations of marble carvers, immigrated to the United States. Within the year he was joined by his father, sister, and brothers Attilio, Furio, Masaniello, Orazio, and Getulio. Although each of the brothers was or was to become a sculptor in his own right, the studio they established in New York was to carve much of the work produced in marble by sculptors working in America from 1888 to 1945. In the production of these marbles they collaborated with Daniel Chester French, Augustus Saint-Gaudens, Frederick MacMonnies, Paul W. Bartlett, Charles Niehaus, Karl Bitter, Loredo Taft, and Edward McCartan, to name but a few; and they designed and/or supplied sculpture and sculptural decoration for such distinguished American architects and firms as Ralph Crane, Bertram Goodhue, Carrere and Hastings, and McKim, Mead and White. Orazio was born in Massa-Carrara in 1872 and, unlike his older brothers who had studied at the Accademia San Luca in Rome or at the academy at Massa, he studied in the family studio and with the French sculptor Edouard Roine in New York. Although most of his work was in collaboration with his brothers, he was personally involved with the architectural carving for the interiors of the Frick and Clark homes in New York City and for the exterior sculpture on the New York City Court House and the Riverside Church. He found little time to exercise his own creative talent, and original works by his own hand are rare. A naturalized citizen of the United States, he died in New York in 1954.

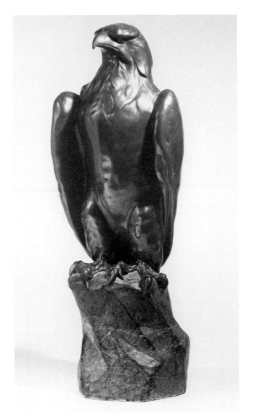

24

24 **Black Eagle**, ca 1926
Black marble, 36½ in (92.7 cm)
Museum purchase, 1930.8
The limited number of non-architectural original works carved by Orazio Piccirilli reveal not only the technical mastery of his craft but also a compositional strength and mature understanding of sculptural form. His *Black Eagle,* carved directly in marble, exhibits these qualities; when shown at the National Academy of Design in 1926, it was awarded the Ellin P. Speyer Memorial Prize.

Frederick George Richard Roth
1872–1944

Born in Brooklyn, New York, Frederick
Roth was educated for a business career in
Bremen, Germany. However, his interest
in sculpture led him to pursue additional
study in art at the Vienna Academy of
Fine Arts and at the academy in Berlin.
Upon his return to the United States he
established a studio in New York City. In
1901 he received international recognition
at the Pan-American Exposition in Buf-
falo, New York, when his vigorously mod-
eled *Roman Chariot Race* became not only a
popular attraction but the center of con-
troversy regarding the traditional limits of
sculpture as a medium for the depiction of
action and movement. He also exhibited
three other animal groups that, though
less noticed, exhibited the interest in and
sculptural mastery of animal forms that
was to make him a leader of the so-called
American *animaliers* and sustain his repu-
tation throughout his career. In 1904 he
modeled architectural ornament for the
St. Louis Exposition. He also exhibited
there and was awarded a silver medal.
He received another silver medal at the
Buenos Aires Exposition of 1910 and a
gold medal at San Francisco's Panama-
Pacific International Exposition in 1915. At
the latter he also collaborated with Alex-
ander Sterling Calder and Leo Lentelli on
the splendid animal and figural groups de-
picting the nations of the east and west
that crowned the monumental arches that
dominated the fair's vast Court of the Uni-
verse. In addition to his animal bronzes,
architectural ornament, and exposition
sculpture, Roth produced portrait busts
and equestrian monuments and ex-
perimented with glazed ceramic sculpture.
He was an associate of the National
Academy of Design where he taught mod-
eling for three years, a member of the
New York Architectural League and the
National Institute of Arts and Letters, and
president of the National Sculpture Soci-
ety. He was appointed chief sculptor for
the New York City Department of Parks
under the Works Progress Administration.
Roth died in New York in 1944.

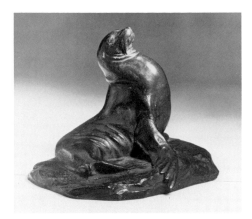

25

25 Sea Lion, 1904
Bronze, 5⅛ in (13 cm)
Markings: Copyright 1904 by / Fred G.R.
Roth / Roman Bronze Works N.Y. (base
rear)
Gift of Archer M. Huntington, 1926.15
In his *Sea Lion,* and the *Bear* and
Greyhound that follow, Roth's emphasis
upon anatomical structure and form over
detail is evident. Realistically modeled in
natural poses, his animals are not zoologi-
cal specimens or trophies but remain vital,
often playful, creatures.

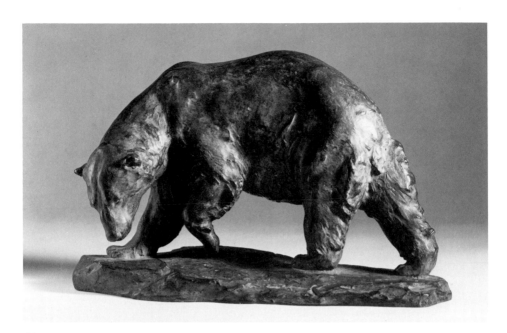

26

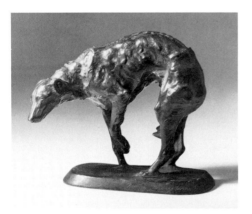

26 Bear, 1904
Bronze, 7 in (17.8 cm)
Markings: Copyright 1904 by / Fredk G. R.
Roth (base rear)
Gift of Archer M. Huntington, 1926.16

27 Greyhound, 1904
Bronze, 5½ in (14 cm)
Markings: Copyright 1904 by Fred. G. R.
Roth (base rear); Roman Bronze Works
N.Y. (base front)
Gift of Archer M. Huntington, 1926.17

27

Arthur Putnam
1873–1930

The son of New England parents whose frequent moves were necessitated by his father's career as a civil engineer, Arthur Putnam was born in Waveland, Mississippi, and spent most of his childhood in Omaha, Nebraska. He manifested a natural talent for drawing and modeling, but he was a strong-willed and rebellious youth and at the age of sixteen set out on his own. After work on a riverboat and a variety of odd jobs, he settled with his widowed mother on a ranch in San Diego County, California. His interest in art and the California Midwinter International Exposition attracted him to San Francisco in 1894, and although he lacked any formal training in art he was accepted as an unpaid assistant in the sculpture studio of Rupert Schmid. He also attended drawing classes at San Francisco's Art Students' League. To support his study, he worked in a slaughterhouse and modeled tiles for the Lincoln Terra Cotta Works. He spent six months working in the Chicago studio of the animal sculptor Edward Kemeys; however, financial problems persisted, and he spent the next few years in Southern California working as a ranch hand, on a surveyor's crew, and as a trapper of pumas for the San Francisco zoo.

In 1899, Putnam married and, determined to make his living as an artist, settled in San Francisco where he took a studio with his friend Gottardo Piazzoni, a painter, and another studio with the sculptor Earl Cummings. By 1901 he had established his reputation, and in addition to modeling a prodigious number of animal and human figures whose originality, vitality, and strength mirrored that of the sculptor, he received architectural commissions from San Francisco architect Willis Polk and a major commission to provide a series of large-scale figures for the San Diego estate of E. W. Scripps. In the modeling of animals, he preferred to work from memory, and his own body served him as a model for human figures.

Despite his apparent success, Putnam continued to have financial problems. Nevertheless, in 1905, through the patronage of Mrs. William H. Crocker, he was able to travel to Europe. His work was exhibited in the Salons at Rome and Paris and received critical acclaim and the praise of Auguste Rodin. Returning to San Francisco late in 1906, Putnam found his beloved city in ruins and the models and plaster casts of his work destroyed. Undaunted, he built a small house and studio in the sand dunes of Ocean Beach near the Cliff House and, working at a feverish pace, created new works, remodeled work that had been destroyed, and modeled numerous architectural commissions for the rebuilding of the city. He provided sculpture and architectural ornament for the St. Francis Hotel, Masonic Temple, Bank of California, Crocker Bank, First National Bank, and the Pacific Union Club; and he modeled the reliefs *The Winning of the West* for the light standards on Market Street's "Path of Gold."

By 1910 Putnam had established his own foundry, was exhibiting at the Macbeth Gallery in New York, and, on the recommendation of Daniel Chester French, one of his animal bronzes had been acquired by the Metropolitan Museum of Art. Just as his success seemed insured, tragedy struck. In 1911, surgery for the removal of a brain tumor ended his career, left him partially paralyzed, and drastically altered his personality. His marriage ended in divorce, and although his work exhibited at the Panama-Pacific International Exposition was awarded a gold medal, his inability to manage money again reduced him to poverty.

In 1921 Alma de Bretteville Spreckels purchased a number of existing bronzes and arranged to have fifty-five of his plaster casts and maquettes cast in duplicate by Alexis Rudier in Paris. One set was presented to the Museum of Fine Arts in San Diego and the other was to go to the proposed California Palace of the Legion of Honor, which Mr. and Mrs. Spreckels were planning as a gift to San Francisco. Putnam went to Paris to supervise the castings and remained in France until his death in 1930.

28 Study of an Old Man, 1905
Bronze, 28½ in (72.4 cm)
Markings: Putnam monogram / '05
(back);
Alexis Rudier. / Fondeur. Paris. (PL base)
Gift of Alma de Bretteville Spreckels, 1924.154
Probably a study for a larger composition,
this boldly-modeled but remarkably sensi-
tive work exhibits Putnam's mastery of
the expressive potential of his medium.

29 Puma Examining Footprints, 1908
Bronze, 13¾ in (34.9 cm)
Markings: A Putnam (encircled) '08 (base
top); © AP (monogram, base edge); Alexis
Rudier. / Fondeur. Paris. (base edge); 37
(under base)
Gift of Alma de Bretteville Spreckels, 1932.21.1
By far the largest part of Putnam's work
consists of animal sculpture, particularly
of the pumas with which he was familiar
from his work as a trapper. Modeled from
memory, his subjects are usually pre-
sented in casual, often playful, attitudes,
and in their execution he is less concerned
with superficial detail than with the grace
and natural beauty of their form.

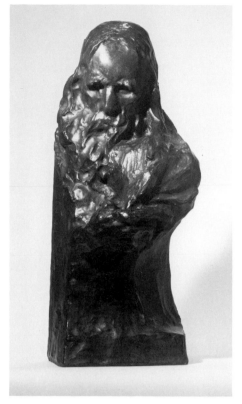

28

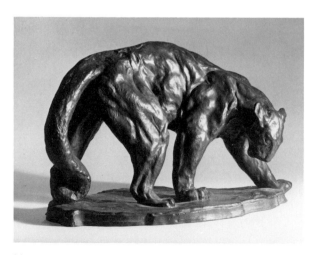

29

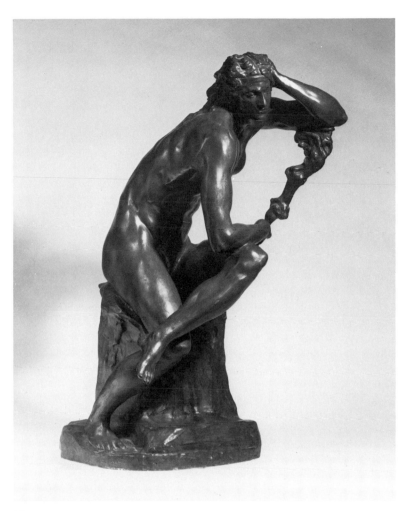

30

30 **Twilight (Venus and Staff)**, 1909
Bronze, 35 in (88.9 cm)
Markings: A Putnam (encircled) '09 /
Alexis Rudier. / Fondeur. Paris. (base); 52
(under base)
Gift of Alma de Bretteville Spreckels,
1932.21.5a
In addition to his well-known animal
sculptures, Arthur Putnam also modeled
human figures. However, female allegori-
cal subjects, which are ubiquitous among
the work of his contemporaries, are quite
rare. In contrast to the svelte gracefulness
that characterizes such subjects produced
within the genteel tradition, Putnam's
Twilight is powerfully modeled, and its
mannered pose and masculine muscula-
ture reveal his familiarity with the work of
both Michelangelo and Rodin.

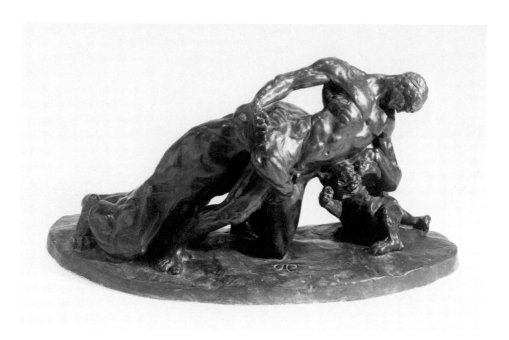

31

31 Combat: Man, Tiger, and Cub
Bronze, 21 in (53.3 cm)
Markings: Putnam monogram (base);
Alexis Rudier. / Fondeur. Paris.
(base side); 44 (under base)
Gift of Alma de Bretteville Spreckels, 1924.165
In modeling this subject of primordial con-
flict, Putnam has presented neither the
violence of attack nor the drama of com-
bat. Rather, his composition presents a
tableau in which the form and anatomical
strength of man and animal are
juxtaposed.

Melvin Earl Cummings
1876–1936

Born in Salt Lake City, Melvin Earl Cummings was reputed to have worked as a woodcarver before moving to San Francisco in 1896. He was awarded a scholarship to study with Douglas Tilden at the Mark Hopkins Institute, and he worked with Arthur Mathews. His progress as a sculptor was rapid and soon earned him the patronage of Phoebe Apperson Hearst, who arranged for him to go to Paris in 1899. Accepted into the Ecole des Beaux-Arts, he studied with Mercié, and during his stay in Paris three of his works, including *La Soif*, now in San Francisco's Washington Square, were shown at the salons. He returned to San Francisco in 1903 and the following year was named instructor of modeling at the University of California and instructor of sculpture at the Mark Hopkins Institute. In addition to fulfilling his teaching responsibilities, Cummings produced numerous portrait busts, statues, and public monuments. Among the last category was the National Monument to Admiral Sloat at Monterey, California, which he did in collaboration with Arthur Putnam. Some of his most important works are in San Francisco's Golden Gate Park and include the statues of Robert Burns and John McLaren, the Doughboy Monument, and the figures of an Indian boy and pumas for the Pool of Enchantment in front of the M.H. de Young Memorial Museum. Cummings was a member of the Bohemian Club and the San Francisco Park Commission and as a trustee of the California Palace of the Legion of Honor served as chairman of the museum's jury of selection for permanent collections. He died in San Francisco in 1936.

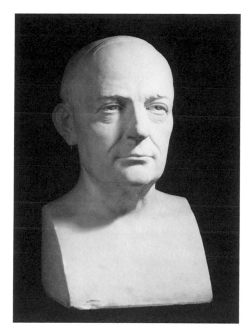

32

32 **Bust of Reuben Lloyd**, 1913
Marble, 26 in (66 cm)
Markings: E. Cummings / 13 (PL side)
Gift of the San Francisco Park Commission,
45070
Reuben Lloyd was born in Ireland around 1835 and came to California in the early 1850s. He studied law, enjoyed a successful practice as a trial lawyer, and assembled what was considered to be the finest private law library west of Chicago. He was active in civic and fraternal organizations and was president of the San Francisco Olympic Club from 1864 to 1874. Lloyd was one of the founders of the Bank of California in 1875 and served as one of the first commissioners of Golden Gate Park. He died in 1909.

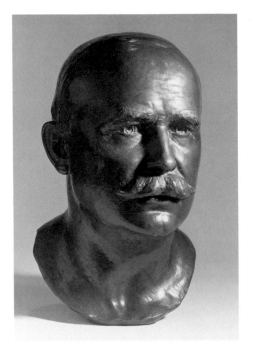

33

Anna Vaughn Hyatt Huntington
1876–1973

Born in Cambridge, Massachusetts, Anna Vaughn Hyatt was to become the most famous of the so-called American *animaliers* and one of America's most successful sculptors. From her father, a distinguished professor of paleontology at Harvard, she inherited the discerning eye of a scientist and an appreciation for all forms of animal life. She studied sculpture with Henry Hudson Kitson in Boston and with Hermon MacNeil and Gutzon Borglum at the Art Students' League in New York. For subject matter she turned to the animals she enjoyed observing in the countryside and on visits to the New York zoo. Her 1902 composition of two dray horses exhibited at the Society of American Artists in 1903 was but the first of many animal sculptures for which she was to become famous.

She traveled and worked in Europe for a time and exhibited at the Paris Salon of 1908 and the Salon of 1910, where her model for an equestrian statue of Joan of Arc received honorable mention. Cast in bronze in 1915, the life-sized statue was erected on Riverside Drive in New York City and established her international reputation. In addition to animal sculpture and equestrian monuments, she produced a relatively small group of figural works which reveal her ability to model the human body. In some of these, notably her *Displaced Persons,* she exhibits not only a mastery of form but a sensitivity to powerful human emotion.

In 1923 Anna Hyatt married Archer M. Huntington. Although she traveled extensively with her husband, she continued to pursue her career. In 1931 Archer M. Huntington created Brookgreen Gardens in South Carolina, a nature conservancy, botanical garden, and a park for the exhibition of sculpture by his wife and other American sculptors. Throughout her long career Anna Hyatt Huntington received countless medals, prizes, and awards. Among the many were an honorary doctor of arts degree from Syracuse University, a special medal for distinction in sculpture from the American Academy of Arts and Letters, and a special medal of honor from the National Sculpture Society.

33 Bust of Alexander F. Morrison, 1924
Bronze, 14¼ in (36.2 cm)
Markings: Cummings 1924 (PL edge);
Roman Bronze Works N.Y. (PR side at bracket edge)
Gift of William Brobeck, 1925.568
Alexander F. Morrison was born February 22, 1856, at Weymouth, Massachusetts, and moved to California with his family when he was eight. Graduated from the University of California and from Hastings College of the Law, he was admitted to the bar in 1881 and practiced law for the next forty years. A gifted lawyer, successful business man, civic leader, and philanthropist, Morrison died in 1921.

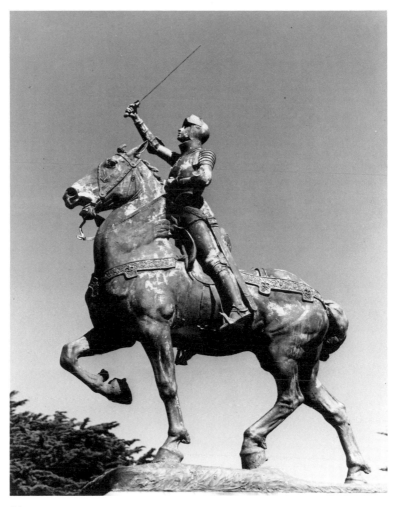

34

34 Joan of Arc, 1915
Bronze, cast ca 1922, 12 ft ⅛ in (366.1 cm)
Marking: Gorham Co. Founders (PL side, bronze base rear)
Gift of Archer M. Huntington, 1926.160
When the original bronze version of Anna Hyatt's equestrian *Joan of Arc* was unveiled in New York, the sculptor was awarded the purple rosette of the government of France and was subsequently made a chevalier of the Legion of Honor. The monument also earned her Philadelphia's Rodin Gold Medal and the Sultis Medal of the National Academy of Design.

The San Francisco bronze presented to the California Palace of the Legion of Honor by Archer M. Huntington in 1926 is one of four full-sized replicas cast from the original. The others are at Blois, France; Gloucester, Massachusetts; and on the Plains of Abraham, Quebec.

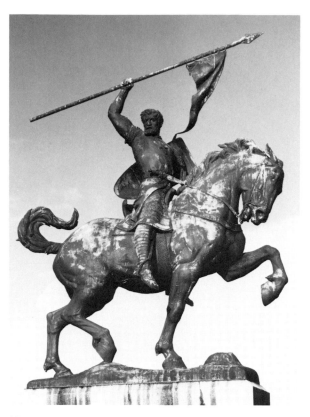

35

35 El Cid Campeador, 1921
Bronze, cast ca 1927, 14 ft 8¾ in
(448.9 cm)
Markings: Anna Hyatt Huntington 1921
(PL side, bronze base rear)
Gift of Herbert Fleishhacker, 1937.11
Inspired by her husband's interest in Spain
and his translation of the *Poema del Cid,*
Anna Hyatt Huntington modeled the
heroic equestrian figure of the Spanish
hero Ruy Diaz de Bivar who came to be
known as El Cid Campeador. The monu-
mental figure was cast in bronze in 1927
and erected in Seville, Spain. The San
Francisco bronze presented to the Califor-
nia Palace of the Legion of Honor in 1937
is one of four full-sized replicas cast from
the original. The others are at Buenos
Aires, the Hispanic Society of America
in New York City, and Balboa Park in
San Diego.

36 Bust of Collis P. Huntington, 1927
Bronze, 23½ in (59.7 cm)
Markings: Anna Hyatt Huntington / 1927
(PL above base); Roman Bronze Works
NY (rear base)
Gift of Archer M. Huntington, 1927.23
Collis Potter Huntington was born in
Connecticut in 1821. He went into busi-
ness with his brother in Oneonta, New
York, before moving to California in 1849.
Settling in Sacramento, he prospered in
the trade of mining supplies and general
merchandise. His success provided him
with capital to invest in a railroad venture
that was to become the powerful South-
ern Pacific Company. Considered the most
brilliant of the magnates who built the
transcontinental railroad, Huntington
moved to New York where he exerted his
considerable financial power and political
influence in the creation of a vast personal
empire. He acquired the Chesapeake and
Ohio Railroad in 1867, and by 1880 per-
sonally owned or controlled rail lines
stretching from coast to coast. In addition,
he operated a steamship line, developed
the port of Newport News, and had finan-
cial and trading interests in Mexico, Brazil,
and China.

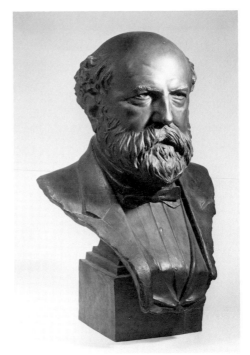

36

37 Bust of Archer M. Huntington, 1927
Bronze, 23¼ in (59.1 cm)
Markings: Anna Hyatt Huntington / 1927
(PL above base); Roman Bronze Works
NY (rear base)
Ref. no. X1982.10
Archer M. Huntington was born in New
York in 1870. Following the marriage of
his mother, Arabella Duval Yarrington
Worsham, to Collis P. Huntington in 1884,
he became the adopted son and heir of the
powerful railroad magnate and capitalist.
A scholar and author, he wrote numerous
texts on Spain and in 1897 published a
three-volume translation of the *Poema del
Cid.* He founded the Hispanic Society of
America and served as officer or trustee of
many philanthropic, art, educational, and
historical organizations. He was a major
benefactor of the California Palace of the
Legion of Honor. The Collis P. Huntington
Memorial bequest, which he presented
following the death of his mother, formed
the nucleus of the museum's collection of
eighteenth-century French decorative
arts. His gifts of American sculpture in-
cluded works by his wife, Chester Beach,
Frederick Roth, Carl Jennewein, and Har-
riet Frishmuth.

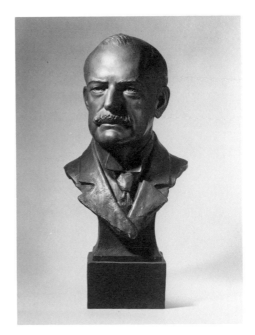

37

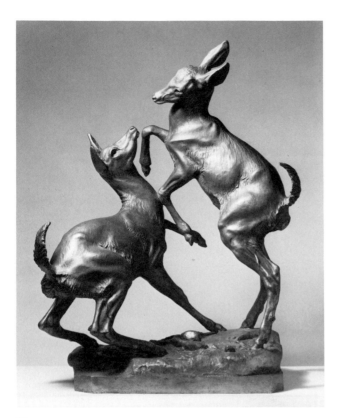

38

38 **Fawns Playing,** 1936
Aluminum, 42 in (106.7 cm)
Markings: Anna Hyatt Huntington 1936
(base, below crouching fawn's tail)
Gift of the artist, 1939.11
Anna Hyatt Huntington was one of the
first American sculptors to experiment
with casting sculpture in aluminum, and
both this figure and *Greyhounds Playing* are
in that medium. Though they are similar
in scale and concept, they were not con-
ceived *en suite.* However, each exhibits the
sculptor's ability to render expressive fig-
ures of domestic and wild animals in ac-
tion, and they exemplify the careful mod-
eling of form and detail that characterized
her work. *Fawns Playing* was also cast in
bronze, and half-sized reductions are
known.

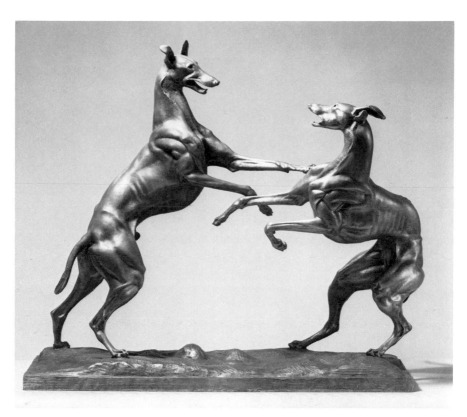

39

39 Greyhounds Playing, 1936
Aluminum, 39 in (99.1 cm)
Markings: Anna Hyatt Huntington 1936
(base, behind tallest dog); Roman Bronze
Works N.Y. (base, PL front corner)
Gift of the artist, 1939.12
In this animated depiction of dogs at play,
modeled in 1936, the sculptor returned to
a favorite subject of the early years of her
career. Exhibited at the Pennsylvania
Academy of the Fine Arts in 1937, it was
awarded the Widener Gold Medal for
Sculpture. Castings were made in both
bronze and aluminum.

Haig Patigian
1876–1950

Haig Patigian was born in Van, Armenia, where his parents were on the faculty of the American Mission School. His father was forced to flee Armenia for political reasons, but in 1891 the family was reunited and settled in Fresno, California. Patigian worked as a day laborer in the surrounding vineyards until he secured a position as a sign painter in 1893. Surviving works, including pen-and-ink drawings and watercolors, indicate a more serious and creative artistic production during this period of his life, and in 1899 he moved to San Francisco and enrolled in the Mark Hopkins Institute of Art. The following year he began work with the art department of the San Francisco *Bulletin.* However, he had become interested in sculpture and in 1906 went to Paris where he pursued independent study, received occasional criticism from Alix Marquet, and exhibited an allegorical figure entitled *Ancient History* at the Salon of 1907. Returning to San Francisco, he established a studio and in the course of a long and successful career became one of the most prominent sculptors on the West Coast. He contributed architectural ornament and exhibited at both the Panama-Pacific and Golden Gate International Expositions and was named to the International Jury of Awards for sculpture at the Tenth Olympiad in Los Angeles.
Among his major works are monuments to President McKinley (Arcata, California), Thomas Starr King (Statuary Hall Washington, D.C.), Abraham Lincoln, General Pershing, and the Volunteer Firemen (all in San Francisco). He provided pediment sculpture for the Metropolitan Life Insurance Building, San Francisco, and the Department of Commerce, Washington, D.C., as well as the sculpture for the original tympanum (now destroyed) at the entrance to the M.H. de Young Memorial Museum. He was an accomplished sculptor whose portraiture is characterized by its verisimilitude, and his architectural and allegorical figures perpetuated the classical tradition well into the twentieth century. Regrettably, his

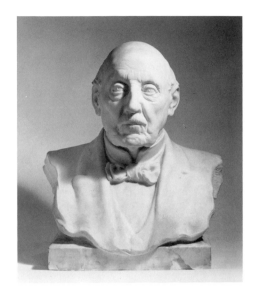

40

success limited his production of sculpture that was more personally expressive, and examples like the powerfully modeled *Friendship,* which was exhibited at the Panama-Pacific International Exposition, are rare. He served three terms as president of the Bohemian Club and was a member of the Press Club, the Olympic Club, the National Sculpture Society, and the National Institute of Arts and Letters. He died in 1950.

40 Bust of John M. Keith, 1913
Marble, 22½ in (57.2 cm)
Markings: Haig / Patigian / 1913 (PR base)
Gift of John M. Keith, 40915
John Keith's background is unknown. He was living in California in 1868 when he petitioned for the incorporation of the city of Gilroy and was elected its first town clerk. Active in Masonry, he served as Master of the Gilroy Lodge that was to bear his name. Sometime after 1871 he moved to Bakersfield, California, and by 1906 he was living in San Francisco. He donated $150,000 to the University of California as a memorial to his wife, who had died in the aftermath of the earthquake, and he died in 1914.

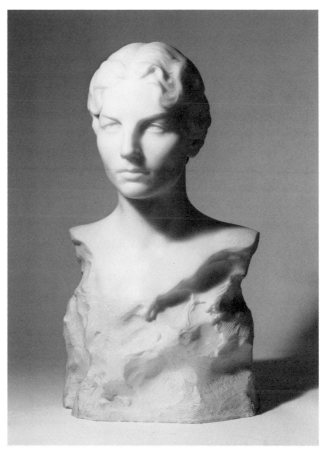

41

41 **Bust of Helen Wills,** 1927
Marble, 26 in (66 cm)
Markings: Haig / Patigian / 1927 (PR lower
front corner)
Gift of James D. Phelan, 1928.21
Born in Centerville, California, Helen
Newington Wills rose to near legendary
fame in women's singles tennis competi-
tion in the 1920s and 1930s by winning
the championships of the United States
six times, of France four times, and of
England eight times. Attractive, athletic,
intelligent, and artistic, Helen Wills
epitomized what Patigian regarded as the
California Woman and perceived as a new
type of classic feminine beauty. In this
portrait, which he called "Helen of Cali-
fornia," he self-consciously sought to
model his subject as an ideal of that type.

Herbert Haseltine
1877–1962

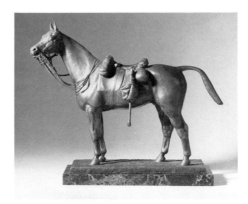

42

Herbert Haseltine was born in Rome, the
son of William Stanley Haseltine, the
Philadelphia-born landscape painter
whose brother James Henry was a
sculptor also living in Rome. He exhibited
an interest in drawing as a child, and his
parents encouraged that interest. Edu-
cated at the Collegio Romano and Harvard
University, he returned to Europe for
study at the Royal Academy in Munich
and with Alessandro Morani in Rome.
This was followed by two years of study
at the Académie Julian in Paris. In 1905
Haseltine began study with Aimé Morot
who suggested that he experiment with
sculpture as an aid to the study of form
and composition for his pictures. The ex-
periment proved successful, and in 1906
he exhibited an equestrian group depict-
ing polo players, which won him not only
an honorable mention but orders for
replicas and commissions for equine
portraits in bronze. As his technique
evolved he became fascinated with the
beauty of materials and developed an
interest in patinas for his work. His career
was interrupted by service in World War I,
and when he resumed his work he had
become strongly influenced by what he
referred to as the "plastic beauty of Egyp-
tian sculpture" in the Louvre. This trans-
formation of style was realized in the
series of twenty British champion animals
first shown in Paris in 1925. In that same
year Haseltine traveled to India to execute
a commission for the Maharaja of
Nawanagar. This was the first of numer-
ous commissions for India which form the
third period in his career. The war years
were spent in the United States, where
he was given exhibitions at a variety of
museums and galleries, including the Cali-
fornia Palace of the Legion of Honor,
Cleveland Museum of Art, Yale University
Art Gallery, and Wildenstein's in New
York City. He was elected a member of the
National Academy of Design in 1945.
Haseltine returned to Paris in 1947 where
he died in 1962.

42 **The Empty Saddle**, ca 1921
Gilt Bronze, 11⅝ in (29.5 cm)
Markings: Herbert Haseltine / Lithinot
fondeur Paris (base)
Gift of Walter Selby McCreery, 1964.111
Haseltine, in France during World War I,
was initially named attaché and later spe-
cial assistant to the United States ambas-
sador. In this capacity he served as an in-
spector of prisoner of war camps. After the
United States entered the war, he joined
the American military mission with the
French army and served as liaison be-
tween the camouflage section and the
army artillery. His exposure to the war
exerted an influence upon his work of
that period which can be seen in his
Soixante Quinze (also called *Field Artillery*)
in the collection of the Smithsonian In-
stitution, *Les Revenants* at the Luxembourg
Museum, and this reduction of *The Empty
Saddle,* a memorial honoring
the fallen members of the Cavalry Club
in London.

43

43 Suffolk Punch Stallion: Sudbourne
Premier, 1921 – 24

Gilt bronze with lapis-lazuli, onyx, and
ivory, cast 1937, 22 in (55.9 cm)
Markings: Herbert Haseltine /
MCMXXXVII (rear of black marble base)
Mildred Anna Williams Collection, 1937.10
The *Suffolk Punch Stallion* is one of a series
of portraits of British champion animals
that Haseltine originally sculpted in stone
between 1921 and 1924. Versions were
cast in bronze and were widely exhibited.
A complete set of twenty is in the collec-
tion of the Field Museum of Natural His-
tory in Chicago. Bred by the Right Honor-
able Lord Manton and owned by Percy C.

Vestey, Esq., of Easton Park, Wickham
Market, in Suffolk, Sudbourne Premier
was named first and champion at the
shows of the Royal Agricultural Society of
England in 1921 and 1922. Another ver-
sion of the *Suffolk Punch Stallion* differing
in the treatment of the braided mane is
known, as are half-size reductions.

Albert Laessle
1877–1954

Albert Laessle, the son of a German immigrant and carver, was born in Philadelphia. He attended the Spring Green Institute, graduated from Drexel University in 1897, and entered the Pennsylvania Academy of the Fine Arts in 1901. There he studied with Thomas Anshutz and became the protégé of Charles Grafly. One of the works that he exhibited in that year, an animal group entitled *Turtle and Crab*, was denied a gold medal when it was falsely charged that the figures had been cast from life. He was vindicated two years later when he exhibited another group, *Turtle and Lizard*, which was irrefutably modeled directly in wax. The model was purchased by the Academy to be cast in bronze, and Laessle received the Stewardson Prize.

In 1904 he was awarded the Cresson Traveling Scholarship and spent three years in Paris where he studied with Michel Beguine. Although he modeled the obligatory portrait busts and figures, his interest in animal subjects was becoming more compelling. In these subjects his sculpture was based upon keen observation of animal anatomy and behavior, and with his return to Philadelphia he maintained both town and country studios and often modeled from life at the Philadelphia zoo. His work was well-received, by both the public and critics; he was awarded a gold medal in Buenos Aires in 1910, the Pennsylvania Academy Fellowship Prize, a gold medal at the Panama-Pacific International Exposition in 1915, and the Widener Gold Medal in 1918. He was appointed to the faculty of the Pennsylvania Academy in 1921 and remained there until he retired in 1939. Laessle's preference for animals as subject and his technical virtuosity as a sculptor made him a leading figure among the so-called American *animaliers*. However, his considerable ability in this specialized area brought him few major public commissions, and his name fell into relative obscurity soon after his retirement. In 1944 he moved to Miami, Florida, where he died in 1954.

44 Penguins, 1917
Bronze, 35½ in (90.2 cm)
Markings: Albert Laessle Germantown Phila.1917 (base rear) Roman Bronze Works N.Y. (rim of base rear)
Museum purchase, 1930.4
Penguins was originally commissioned from Laessle for the birdhouse at the Pittsburgh residence of R.K. Mellon. Exhibited at the Pennsylvania Academy in 1918, it was awarded the Widener Gold Medal and received an honorable mention when shown at the Art Institute of Chicago in 1920. Four bronzes were cast from the original: one for the Mellon family, one for the Fairmount Park Association, now in the Philadelphia Zoological Gardens, one now at Brookgreen Gardens in South Carolina, and the one acquired for the California Palace of the Legion of Honor from the National Sculpture Society in 1930.

44

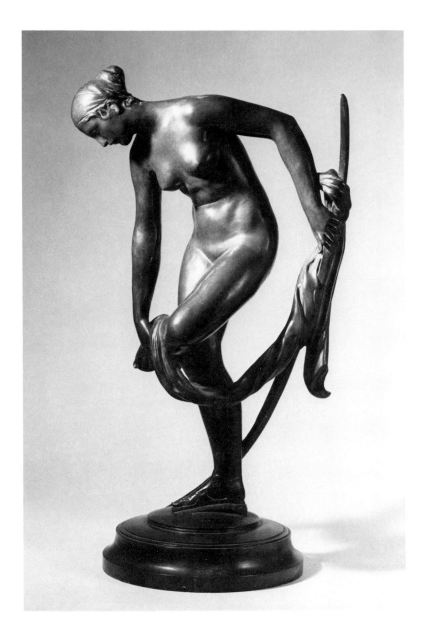

45

Robert Ingersoll Aitken
1878–1949

Born in San Francisco in 1878, Robert Ingersoll Aitken was an artistic prodigy whose remarkable talent evinced itself while he was a student at Lick High School. Following his graduation, he studied for a year with Arthur Mathews and Douglas Tilden at the Mark Hopkins Institute of Art, and at the age of eighteen he set up his own studio in San Francisco. He studied briefly in Paris but returned to San Francisco where, in spite of his youth and relative lack of training or experience, he was soon entrusted with some of the most prestigious commissions in the city. In 1900 he modeled the bronze doors for the Crocker mausoleum and carved the heroic figures for the spandrels of the Claus Spreckels Music Pavilion erected on the concourse in Golden Gate Park. The following year, at the age of twenty-three, he was appointed professor of sculpture at the Mark Hopkins Institute and received the commission for the monument to Admiral Dewey which, with its eighty-three-foot column, centers San Francisco's Union Square. In 1904, his monument to President McKinley was unveiled at the entrance to the panhandle of Golden Gate Park.

He returned to Paris to work for three years, and in 1907 he opened a studio in New York City and began teaching at the Art Students' League. He exhibited three works at the Armory Show in 1913 and participated in international expositions and exhibitions around the world. For the Panama-Pacific International Exposition he supplied four heroic figures of the elements for the Court of Honor and the extraordinary Fountain of the Earth, a complex allegory of the psychology of life, for Louis Mullgardt's Court of the Universe.

Aitken was a prolific artist whose work ranged from the design of coins and commemorative medals to the pediment sculptures for the United States Supreme Court Building. He was an academician of the National Academy of Design, a member and officer of the National Institute of Arts and Letters, and he served as president of the National Sculpture Society. His numerous awards included the Barnett Prize and the Watrous and presidents medals of the National Academy of Design, the Medal of Honor of the New York Architectural League, the silver medal for sculpture at the Panama-Pacific International Exposition, and San Francisco's Phelan Gold Medal. Aitken died in New York City in 1949.

45 Diana
Bronze, 31⅜ in (80 cm)
Markings: Aitken (base top)
Museum purchase, 1930.5
A conservative rendering of a traditional subject, Aitken's *Diana* demonstrates the sculptor's perpetuation of the genteel tradition in American sculpture and contrasts with the sensual modeling and emotional content of works such as *A Creature of God til Now Unknown*, which he exhibited at the Armory Show in 1913. Both figures were exhibited by the artist in the National Sculpture Society's exhibition of contemporary American sculpture at the California Palace of the Legion of Honor in 1929.

Harriet Whitney Frishmuth
1880–1980

Born in Philadelphia, Harriet Frishmuth
had a cosmopolitan childhood residing in
France, Switzerland, Germany, Austria,
and Italy and attending private schools in
Philadelphia, Paris, and Dresden. She de-
veloped an interest and talent for model-
ing figures and at the age of nineteen en-
rolled in Rodin's class for women in Paris.
Although her study with Rodin was brief,
his influence upon her work was consid-
erable. She took additional study with
Henri-Desiré Gauquié and Jean-Antoine
Injalbert in Paris and spent two years
working with Cuno von Euchtritz in Ber-
lin. Returning to America, she studied
with Herman MacNeil and Gutzon
Borglum at the Art Students' League.
Upon completion of her study she worked
with Borglum and Karl Bitter before estab-
lishing her own studio in New York City.
In 1916 she met Desha, a talented young
dancer who was to become her favorite
model and whose dancing was to inspire
many of her sculptures. These works, usu-
ally small bronzes, possess the vitality and
lyrical quality that characterize the best of
her sculpture. Frishmuth was an academi-
cian of the National Academy of Design
and a fellow of the National Sculpture
Society. She died in 1980 at the age of
ninety-nine.

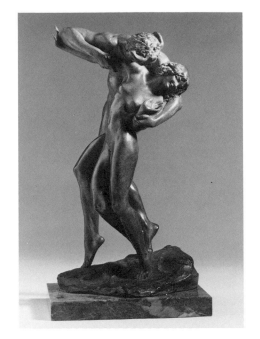

46

46 Fantaisie, 1922
Bronze, 10¼ in (26.7 cm)
Markings: © / 1922 / Harriet W. Frishmuth
(PL base); Amer Art Fdry N.Y. (base rear)
Gift of Archer M. Huntington, 1926.18
Much of Harriet Frishmuth's work was
inspired by the dance, and in *Fantaisie,*
which was awarded the Watrous Gold
Medal of the National Academy of Design
in 1922, she has depicted the dancers
Desha and Léon Barté as nymph and satyr.

Chester Beach
1881–1956

Chester Beach was born in San Francisco, studied architectural modeling at Lick Polytechnic High School, and supported himself as a silver designer while he studied drawing at the Mark Hopkins Institute of Art. He left San Francisco in 1904, studied at the Académie Julian in Paris, and in 1907 established himself as a sculptor in New York City where, with the exception of extended visits to Rome in 1911–1912 and 1927–1928, he was to spend the rest of his life.

Beach was a versatile artist who addressed a wide range of subjects in a variety of mediums. His idealized works have tended to associate him with the academic tradition; however, his realistically modeled depictions of everyday life relate to the works of the realist sculptors Abastenia St. Leger Eberle and Bessie Potter Vonnoh, and his bronzes of working men were contemporary with those of Mahonri Young. He was awarded the Barnett Prize and Watrous Gold Medal by the National Academy of Design, the Medal of the Architectural League of New York, the Potter Palmer Gold Medal of the Art Institute of Chicago, and the Lindsey Morris Memorial Prize of the National Sculpture Society. Beach was a member of the National Academy of Design, the Architectural League of New York, the National Institute of Arts and Letters, and he was president of the National Sculpture Society.

47

47 **Beyond**, 1911–12
Marble, 62¼ in (158.1 cm)
Markings: Beach (PL side above base)
Gift of Archer M. Huntington, 1926.19
Modeled and cut in marble while Beach was in Rome between 1911 and 1912, this figure, in spite of its allegorical title, exhibits few of the conventions that characterize the feminine ideal of the academic tradition. Rather, it is a realistically rendered study of an adolescent girl, tentative, ungainly in her stance, not yet a woman.

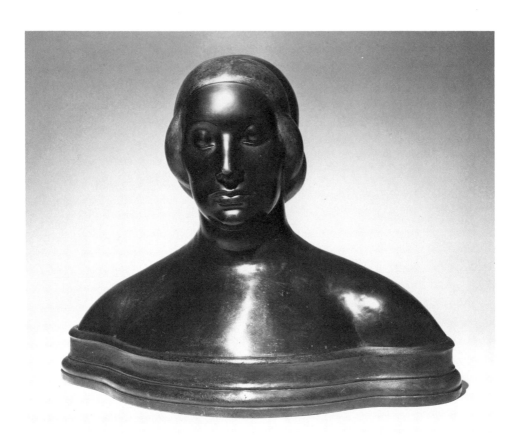

48

Gaston Lachaise
1882–1935

The son of a French cabinetmaker, Gaston Lachaise was born in Paris. After three years of study at the Ecole Bernard Palissy, he entered the Ecole des Beaux-Arts in 1895. Although he was to continue his studies at the latter, he questioned the classical emphasis of his instruction and became increasingly involved with the circle of avant-garde young artists who were active in Paris at that time. In 1902 he met Isabel Nagle, an American who was to become his mistress, later his wife, and the principal influence upon his art. Lachaise worked for a year for René Lalique before immigrating to the United States in 1906. He settled first in Boston, where he was employed as an assistant in the studio of Henry Hudson Kitson. In 1912 he set up his own studio in New York City and supported himself by working in the studio of Paul Manship. The following year he and Isabel were married. During this period he continued to develop his own personal style and, along with Robert Henri, John Sloan, and Gertrude Whitney, became a member of the Society of Independent Artists. Although Lachaise exhibited at the Armory Show, his work attracted little attention until 1918 when a one-man exhibition at the Stephen Bourgeois Gallery brought him critical if controversial recognition. He received some commissions, notably the United States Coast Guard Monument in the Arlington National Cemetery and architectural compositions for Rockefeller Center, but the greater part of his work consisted of his studies of the human—and more specifically the female—body, a theme which emerged early in his career and was developed throughout his life. In its emphasis upon mass and volume and in its explicit sexuality, Lachaise's sculpture contrasted dramatically with the waning academic tradition and placed him in the vanguard of American sculpture of the twentieth century.

In 1923 he relocated his studio to Georgetown, Maine. He died of leukemia in 1935, the year of his first retrospective exhibition at New York's Museum of Modern Art.

48 Bust of Mrs. Lachaise, 1912–27
Bronze, cast 1927, 17½ in (44.5 cm)
Markings: G. Lachaise (back of PL shoulder); A. Kunst / Bronze Wks. N.Y. (back of PR shoulder)
Dr. T. Edward and Tullah Hanley Memorial Collection, 69.30.113
This portrait of Isabel Nagle Lachaise is actually a version of the sculptor's seventy-inch, full-length figure entitled *Standing Woman.* First modeled in 1912, the figure was refined over the next fifteen years before being cast in bronze in 1927. Isabel was both model and inspiration to Lachaise. It is traditionally assumed that the *Standing Woman* is a portrait of her, and a comparison of the bronze with photographs reveals the fidelity of the likeness.

Elie Nadelman
1882–1946

The son of Polish-Russian parents, Elie Nadelman was born in Warsaw and grew up in a prosperous, art-conscious environment. He studied at the academy in Warsaw; however, the collections of folk art that he saw in Munich and the antiquities collections there and in Paris were to exert a more profound influence upon his art. In Paris, he found a climate conducive to his intellectual and creative growth, and he worked there from 1903 to 1914.

Although Nadelman was initially influenced by Rodin and his followers, his independent analytical study of curves and countercurves, contour and volumetric relationships, both in drawing and sculpture, coincided with that of the early cubists, and he was drawn to the circle of avant-garde young artists who were experimenting with new concepts of artistic expression. Involved with the intellectual interchange of the circle of Leo and Gertrude Stein, Picasso, Matisse, and André Gide, he became an articulate spokesman for his personal concepts of modern art. By 1911 he had attracted the patronage of Helena Rubenstein, who assisted in popularizing his works by placing examples of his beautifully executed, sophisticated sculpture on display in her stylish salons in Europe and America. He exhibited at the Armory Show in 1913 and the following year set up his studio in New York City. His work was seminal to the non-traditional concepts emerging in American Art, and his international reputation and retention of the figure as the basis of his elegant abstractions contributed to the popular acceptance of some of those concepts.

In 1919 he married the wealthy widow of Joseph A. Flannery. In the decade that followed, his work became less daring and more overtly influenced by the collection of folk art he assembled. That collection and most of their wealth were lost in the aftermath of the 1929 crash, and in 1935 many of his sculptures were inadvertently destroyed during the renovation of his studio. The last years of his life were spent in relative seclusion, and he died in 1946.

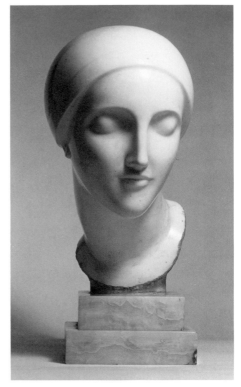

49

49 **Ideal Head**, ca 1910
Marble, 16 in (40.6 cm)
Markings: Elie Nadelman (PL neck, rear)
Bequest of Hélène Irwin Fagan, 1975.5.20
The *Ideal Head* is one of a series of classicizing female heads that Nadelman executed in marble around 1910. In this example his debt to the Greek ideal is evident; however, in the mannered simplification of the features, his concepts of what he termed "significant form" are clearly articulated.

50 **Buck Deer**, ca 1915
Bronze, 30 in (76.2 cm)
Bequest of Hélène Irwin Fagan, 1975.5.18
In his exquisitely modeled *Buck Deer* and *Doe with Lifted Leg,* Nadelman's mature style is in evidence. Anatomical structure has been subordinated to significant form, which is articulated in curving volumes borne effortlessly upon the gracefully attenuated legs.

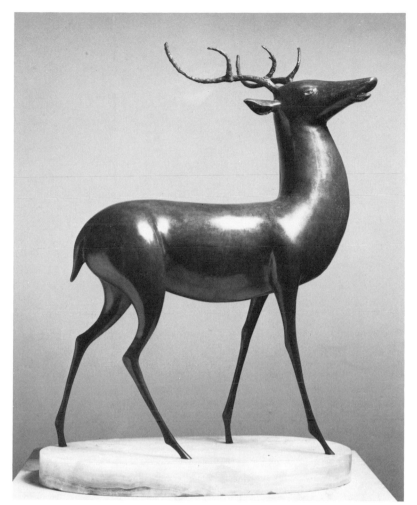

50

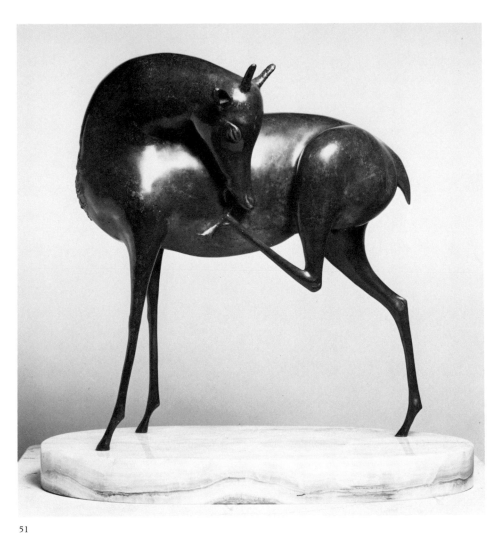

51

51 **Doe with Lifted Leg**, ca 1915
Bronze, 21 in (53.3 cm)
Bequest of Hélène Irwin Fagan, 1975.5.19

52 **Bust of Hélène Irwin Fagan,** 1917
Marble, 25⅜ in (64.5 cm)
Bequest of Hélène Irwin Fagan, 1975.5.21
Born in Hawaii, Hélène Irwin was the
daughter of William G. Irwin. A former
partner of Claus Spreckels, Irwin was a
sugar planter with large land holdings in
the islands, served on the Council of State
for Hawaii's King Kalakaua, and was
founder and president of San Francisco's
Mercantile Trust Company. From a privi-
leged childhood spent in Honolulu and
San Francisco, Hélène grew to be a
woman of elegant personal style who de-
veloped a love for art and a passion for
collecting. Although her collections in-
cluded Franco-Flemish tapestries,
medieval furniture, Romanesque and
Gothic sculpture, and oriental jades, her
taste in contemporary sculpture favored
the stylish simplifications and abstraction
of the work of a group of young sculptors
who were to challenge the entrenched
academic tradition of her day. Her first
marriage ended in divorce, and in 1929
she married Paul I. Fagan. Following her
death in 1966, much of her collection, in-
cluding this bust and other works by
Nadelman, Manship, and Archipenko,
was presented to the California Palace of
the Legion of Honor.

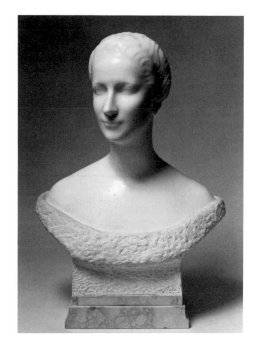

52

Jo Davidson
1883–1952

Born in New York City, Jo Davidson spent his childhood in poverty and of necessity began to work at an early age. Although he was interested in art, there was neither time nor money for formal study; so his initial instruction was limited to attendance at evening drawing classes. In 1899 he received a scholarship, which enabled him to study with George de Forest Brush at the Art Students' League in New York. At his parents' urging he enrolled in the School of Medicine at Yale University; however, he soon withdrew and returned to the Art Students' League to study sculpture and work as an assistant in the studio of Hermon A. MacNiel. In 1907 he went to Paris for study at the Ecole des Beaux-Arts, but he was more impressed by the freedom he saw in works exhibited at the Salon des Artistes Indépendants than with his instruction at the Ecole and withdrew to pursue independent study. He returned to New York in 1910, and in 1913 he exhibited seven works at the Armory Show.

Davidson's interest in and talent for modeling portrait busts was enhanced by his service as a correspondent during World War I, and following the war he began an ambitious project to model the portraits of the military and political leaders of the Allied Campaign. To these he was to add an impressive list of some of the most eminent statesmen, politicians, industrialists, and men of letters of his time. In these portraits, quickly modeled, usually in a single sitting, Davidson achieved not only the likeness but also something of the character and personality of his sitter. He was a chevalier of the Legion of Honor, and in 1934 he was awarded the Maynard Prize of the National Academy of Design. He died in France in 1952.

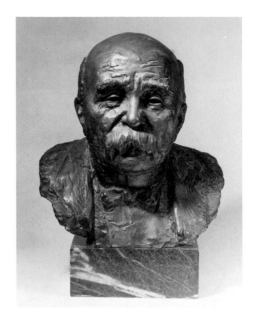

53

53 **Bust of Georges Clemenceau**, 1920
Bronze, 15⅛ in (38.4 cm)
Markings: G. Clemenceau (lower front); Jo Davidson, Cire / C. Valsuani / Perdue (stamp); Modeled 8 Rue Franklin, Paris, Jan. 21, 1920 (PR shoulder, rear)
Museum purchase, 1930.6
A distinguished French statesman, Georges Clemenceau served as a member of the Chamber of Deputies and as a senator before being elected premier of France, a position he held from 1906 until 1909. Again premier in 1917, he guided his nation through the most critical days of World War I, and in 1919 he served as the head of the French delegation at the Conference of Versailles, which negotiated the peace treaty that ended the war.

Paul Manship
1885–1966

Paul Manship was born in St. Paul, Minnesota, where he spent his childhood and began his study of art. In 1905 he went to New York, and after working in the studios of Solon Borglum and Isidore Konti, he went to Philadelphia where he studied with Charles Grafly at the Pennsylvania Academy of the Fine Arts. He received a fellowship for study at the American Academy in Rome in 1909. By going to Rome he avoided the powerful influences of the Ecole des Beaux-Arts and Rodin. He was exposed instead to the frescoes, sculpture, and architecture of Italian antiquity and, in his travels, to the pre-classic art of Greece and Egypt and the cross-cultural art of Gandha

The assimilation of these various influences resulted in a sculptural style that derived from nature but emphasized balance, order, line, and contour over naturalism. Upon his return to New York in 1912, his work was well-received and established a middle ground between the entrenched academic tradition and the emergent work of sculptors influenced by the abstractions of the cubists and constructivists.

Although Manship was to become one of the most influential American sculptors of his day, "modern" art was to prevail and his work came to be viewed as conservative if not, in fact, academic. The recipient of numerous awards and medals, he was a member of the National Academy of Design and the American Academy of Arts and Letters, a fellow of the American Academy of Arts and Sciences, president of the National Sculpture Society, and a chevalier of the Legion of Honor. He died in 1966.

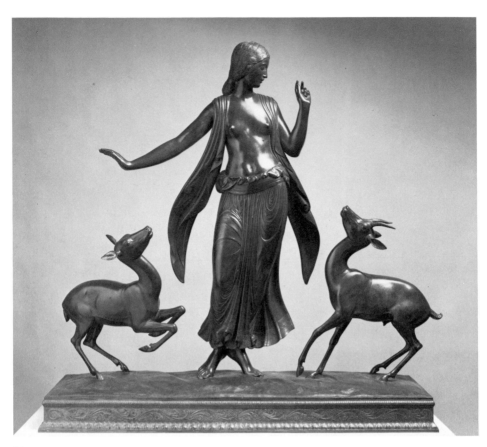

54

54 **Dancer and Gazelles,** 1916
Bronze, 32¼ in (81.9 cm)
Markings: Roman Bronze Works NY
(base, PL rear); Paul Manship/© 1916 (PR
base top)
Bequest of Hélène Irwin Fagan, 1975.5.16
First exhibited in 1916, *Dancer and Gazelles*
was awarded the Barnett Prize for
Sculpture by the National Academy of De-
sign in 1917. A non-classical subject, this
group reveals Manship's debt to oriental
and particularly near-Eastern sculpture
and demonstrates the stylized patterns
and lyrical interplay of line, form, and
void that characterized his early work.

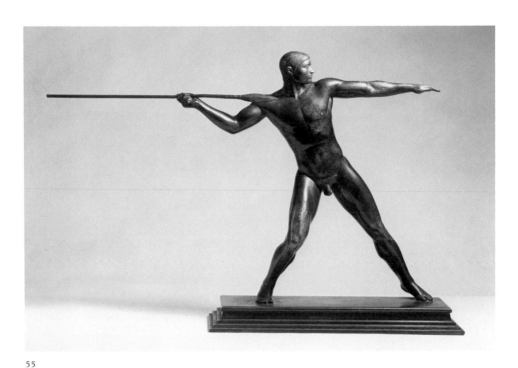

55

55 The Spear Thrower, ca 1921
Bronze, 20 in (50.8 cm)
Markings: Paul Manship / © 1921 (base
top, near PL foot); Roman Bronze Works
NY (base rear, PL edge)
Bequest of Hélène Irwin Fagan, 1975.5.17
In the 1920s Manship became less con-
cerned with the lyrical aspects of his work
and more concerned with stylization of
form. This is evident in the compositional
emphasis upon line and the simplification
of contours and detail of this subject.

Ralph Stackpole
1885–1974

Born in Williams, Oregon, Ralph Stackpole entered San Francisco's Mark Hopkins Institute of Art in 1901. He studied painting with Gottardo Piazzoni and sculpture with Arthur Putnam, and in 1906 he went to Paris where he was a student in the atelier of Antoine Mercier at the Ecole des Beaux-Arts. Returning to the United States, he studied with the painter Robert Henri in New York, and by 1914 he had settled in San Francisco. The following year he received an honorable mention at the Panama-Pacific International Exposition, and in 1923 he was named to the faculty of the San Francisco Art Institute. In that capacity he formalized the course of instruction in sculpture, exerted an influence upon a generation of young sculptors in the Bay Area, and became an outspoken advocate for the revival of the technique of direct carving in wood and stone.
Stackpole traveled extensively in Mexico, and the influence of Aztec architectural carving is evident in the granite fountains that he carved for Sacramento between 1923 and 1927. From 1929 to 1932 he worked on the massive granite figures of *Mother Earth* and *Man and His Inventions* for San Francisco's Pacific Coast Stock Exchange. In addition to making direct carvings, Stackpole modeled figures, executed portrait busts, and in 1939 provided the monumental stucco figure of *Pacifica* for the Golden Gate International Exposition. In 1941 he left the Art Institute and eight years later moved to France where he continued to work until his death in 1973.

56 **Seated Girl**, ca 1915
Stained plaster, 7½ in (19.1 cm)
Markings: Stackpole (PL base front)
Gift of William Hammarstrom, 1966.49
Possibly a study for a larger work, the *Seated Girl* was made shortly after Stackpole's return to San Francisco. Sensitively modeled, it reflects the romantic influence of his training in Paris and exhibits none of the stylized treatment of form that characterizes his later work. The figure was given by the artist to his friend Helliodor Hammarstrom, whose son William presented it to the California Palace of the Legion of Honor in 1966.

56

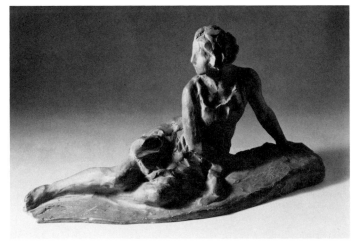

Alexander Archipenko
1887–1964

Alexander Archipenko was born in Kiev, Russia, where he began his study of art. In 1906 he went to Moscow, and although his work was included in several exhibitions there, the prevailing emphasis upon academic classicism provided him with little creative stimulation. In 1908 he moved to Paris and, after a brief period of study at the Ecole des Beaux-Arts, began independent study. In the galleries of the Louvre he became familiar with the forms and aesthetics of Gothic, Assyrian, Egyptian, and Archaic Greek sculpture, and he found among the young artists who were searching for new directions in art the creative atmosphere he had been seeking. Considered one of the progenitors of cubism, he also undertook experiments with the interrelationships of volume and void, new materials, and polychrome. He became associated with Modigliani and Gaudier-Brzeska and with the circle of Picasso, Braque, Gris, Léger, Delaunay, Villon, and Duchamp. Archipenko established his own art school in 1912, and the following year he exhibited four sculptures and five drawings at the Armory Show in New York.

He spent the years of World War I in Nice and in 1921 went to Berlin. Two years later he immigrated to the United States, settled in New York, and again established an art school. Other schools were subsequently opened, including those at Woodstock and Los Angeles. Archipenko became a naturalized citizen of the United States in 1928 and five years later moved to California where he was an instructor at Mills College in Oakland and at the summer sessions of the Chouinard Art School in Los Angeles. He left California in 1937 and for the next two decades traveled and lectured extensively, holding positions as instructor, lecturer, and sculptor-in-residence at art schools, colleges, and universities throughout the country. Although his most creative years had been spent in Paris, he continued to work and experiment.

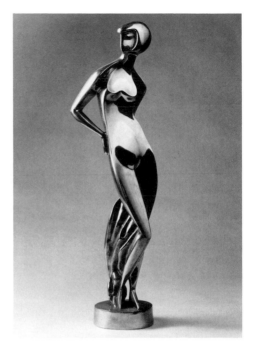

57

One of the most articulate and dedicated teachers of the fundamentals and theory of modern art, he exerted a major influence upon sculpture in America in the twentieth century. He died in New York City in 1964.

57 **Standing Concave**, 1925
Chrome-plated brass or bronze, 18¾ in (47.6 cm)
Markings: Archipenko (drapery back)
Bequest of Hélène Irwin Fagan, 1975.5.13
Although abstraction characterized the avant-garde in modern art, Archipenko retained the form of the human figure as the basis for his innovative art. To the simplification of this essential form he also brought the concept of space as a factor of mass and an emphasis upon the reciprocal integration of relief and concavity. *Standing Concave* is one of the most successful of his female figurative works that embodies all of these principles.

Malvina Hoffman
1887–1966

The daughter of an English concert
pianist, Malvina Hoffman was born in
New York. She began to draw and paint
while a student at the Brearley School and
continued her study of paintings with
John Alexander. She pursued an interest
in sculpture at the Art Students' League
and worked in the studios of Gutzon
Borglum and Herbert Adams. She exhib-
ited a portrait bust of her father at the Na-
tional Academy of Design in 1910, and the
following year she went to Paris where
she studied with Rodin. Aware of the pre-
judice against women sculptors, Hoffman
provided herself with a solid foundation in
the art and craft of sculpture; and, in addi-
tion to taking courses in dissection at New
York's College of Physicians and Surgeons,
she studied the technology of casting,
chasing, and patination. While in Paris she
became acquainted with Anna Pavlova
and the Ballet Russe. From her continued
interest in and association with dancers
and the dance came the inspiration and
subject matter for much of her work. In
1924 she married the English violinist
Samuel Grimson, and in 1927 she traveled
to Zagreb, Yugoslavia, to study with Ivan
Mestrovic.
Hoffman's talent as a portraitist earned her
an international reputation and the com-
mission for her most ambitious project.
Begun in 1930, the commission proposed
the production of a series of figures repre-
senting the races of the earth for Chicago's
Field Museum of Natural History. Modeled
during five years of exhaustive travel, the
completed series numbered 105 figures
and busts. Hoffman also wrote on
sculptural methodology, and her contri-
butions to the art were recognized by the
award of honorary doctoral degrees by
Mount Holyoke College and Rochester
University. She was a member of the Na-
tional Academy of Design, the National
Sculpture Society, and the Architectural
League of New York. She died in New
York in 1966.

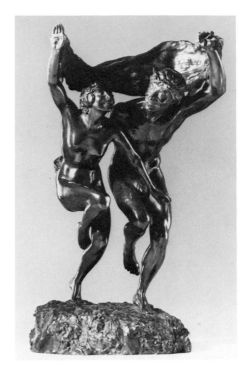

58

58 Pavlova and Mordkin in
"Bacchanale Russe," 1912
Bronze, 14⅛ in (35.9 cm)
Markings: Malvina Hoffman © (PL base
edge); Roman Bronze/Works N.Y. (PR
base edge)
Gift of Alma de Bretteville Spreckels, 1959.62
Malvina Hoffman's interest in the dance
was stimulated by her involvement with
the circle of Pavlova, Nijinsky, and
Diaghilev's company in Paris in the years
preceding World War I. The *Bacchanale
Russe,* modeled in 1912, dates from this
period and depicts Anna Pavlova and
Mikhail Mordkin. Exhibited at the Na-
tional Academy of Design in 1917, it re-
ceived the Julia A. Shaw Memorial Prize.

59 **Pavlova in the "Gavotte,"** 1915
Gilt bronze, 14½ in (36.8 cm)
Markings: ©1915- / Malvina Hoffman (PL
base); Roman Bronze Works N.Y. (base
rear edge)
Gift of Alma de Bretteville Spreckels, 1959.72
Dating from the same period as the *Bac-
chanale Russe,* this figure also depicts Anna
Pavlova. In these studies of the move-
ments and characterizations of dancers,
Hoffman is not striving for psychological
depth or a profound representation of life.
Rather, she celebrates the grace, beauty,
and joie de vivre of the art of the dance.

60 **Study for a Female Dancer,** 1919
Bronze, 8¾ in (22.2 cm)
Markings: Malvina Hoffman © 1919 (PR
base)
Gift of Alma de Bretteville Spreckels, 1959.70
Unlike the *Bacchanale Russe* and *Gavotte,*
this fragmentary study reflects the pro-
found influence of Rodin on Hoffman's
work. Not a characterization, the work
stands upon the merits of its beautifully
modeled sculptural form.

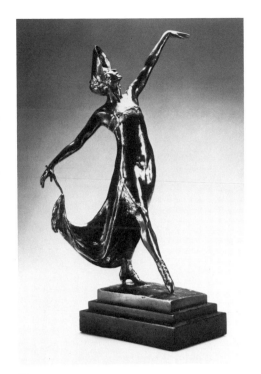

59

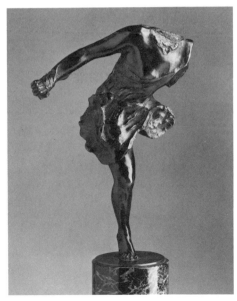

60

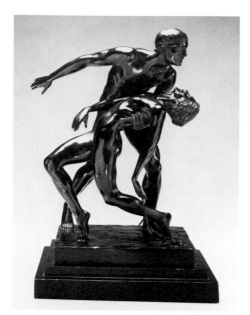

61

61 Pavlova and Novikoff in "La Péri,"
1921
Bronze, 12¼ in (31.1 cm)
Markings: Malvina Hoffman / 1921 (base
top); Cellini Bronze Works- N-Y (base
edge rear)
*Gift of Alma de Bretteville Spreckels, Theater
and Dance Collection, 1962.139*
Modeled after Hoffman's return to the
United States, this depiction of Pavlova
and Novikoff exhibits a lyrical aspect of
her work.

62 **Head of Fosuidi,** ca 1930
Wood, 15⅝ in (39.7 cm)
*Dr. T. Edward and Tullah Hanley Memorial
Collection, 69.30.99*
In addition to modeling figures and
portraits to be cast in bronze, Malvina
Hoffman also experimented with direct
carving in stone and wood. Although con-
sidered a portrait, this head exhibits a
simplification of detail and a stylization
not seen in the other examples of her
work.

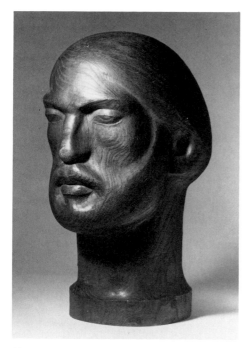

62

Carl Paul Jennewein
1890–1978

Born in Stuttgart, Germany, Carl Paul
Jennewein served an apprenticeship as a
museum technician; and, in addition to
receiving training in painting, modeling,
and casting, he studied art history. He be-
came interested in architecture and in
1907 immigrated to the United States, in-
tending to pursue a career in that field. He
secured a position with a firm in New York
that supplied architectural sculpture and
began to study drawing at the Art Stu-
dents' League and painting with Clinton
Peters. In 1912 he was awarded the Avery
Prize of the New York Architectural
League, which allowed him to return to
Europe for two years of study and travel
in France, Germany, Italy, and Egypt. He
won the Prix de Rome in 1916 and spent
the next three years in study at the Ameri-
can Academy in Rome where, like Paul
Manship, he was strongly influenced by
the decorative elements of Greco-Roman
sculpture. Upon his return to the United
States in 1921 he opened a studio in New
York City. His considerable production was
well-received by the public and the con-
servative critics of his day.

Although his work is frequently compared
with that of Manship, his synthesis of the
classical antecedents was more traditional,
and he became acknowledged as the
leader of the academic tradition in
America. Some of his most important
commissions were for architectural
sculpture and included the reliefs and fig-
ures for the Department of Justice build-
ing in Washington, the bronze doors for
the British Empire building at Rockefeller
Center in New York, and the remarkable
polychromed terra-cotta pedimental fig-
ures for the Philadelphia Museum of Art.
He was a fellow of the American Academy
in Rome, a member of the National Insti-
tute of Arts and Letters, the Century Asso-
ciation, and the Fine Arts Commission
in New York. In addition, he was an
academician and vice president of the
National Academy of Design, a fellow
and president of the National Sculpture
Society, and was named president of
Brookgreen Gardens in 1963. He died in
New York in 1978.

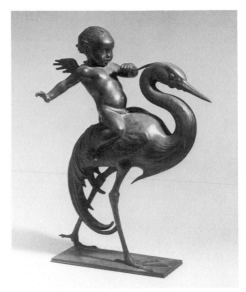

63

63 Cupid and Crane, 1923
Bronze, 21⅜ in (54.3 cm)
Markings: Roma / CPJ (monogram) / 1928
(PR base top)
Gift of Archer M. Huntington, 1926.20
Although not based upon a classical
model, *Cupid and Crane* exhibits the linear
rhythm and compositional harmony,
synthesized from Greek ornamental
sculpture, that characterized much of
Jennewein's work.

Boris Lovet-Lorski
1894–1973

Born in Lithuania, Boris Lovet-Lorski studied at the Imperial Academy of Art in St. Petersburg, Russia, and worked as an architect before immigrating to the United States in 1920. Settling in New York, he worked as a sculptor and became a naturalized citizen in 1925. An acknowledged master of sculptural technique, he worked in bronze, marble, ivory, pewter, slate, and wood. His early work exhibited a decorative style marked by complex rhythms and graceful curves; however, as his style matured, he developed a more intellectual simplification of formal organization and a stylized treatment of his subject matter. In these works he attempted to achieve a synthesis of the linear simplification of art deco design and the formal volumes of sculpture. This is evident in the tight, archaistic depictions of his animal and female figures that established his reputation in both New York and Paris. His ability as a portraitist earned him commissions to model likenesses of such men as Albert Einstein, Albert Schweitzer, Arturo Toscanini, Dwight D. Eisenhower, and John F. Kennedy. Among his major works are the bust of General Charles de Gaulle in the Paris City Hall and the monumental head of John Foster Dulles at Washington's Dulles International Airport. He was a fellow of the National Sculpture Society and a chevalier of the Legion of Honor. He died in New York in 1973.

64 Venus, ca 1925
Bronze, 92½ in (235 cm)
Markings: Boris Lovet-Lorski (PR base top); Fonderie Anoro / Paris France (base rear edge)
Gift of Mrs. Frank Short, 1958.53
In this monumental version of a traditional ideal subject, Lovet-Lorski displays the archaistic stylization and graceful aloofness that characterizes his mature work. Although the attitude of the head elicited the designation of "the broken-neck school," the figure possesses a sensitive and lyrical beauty.

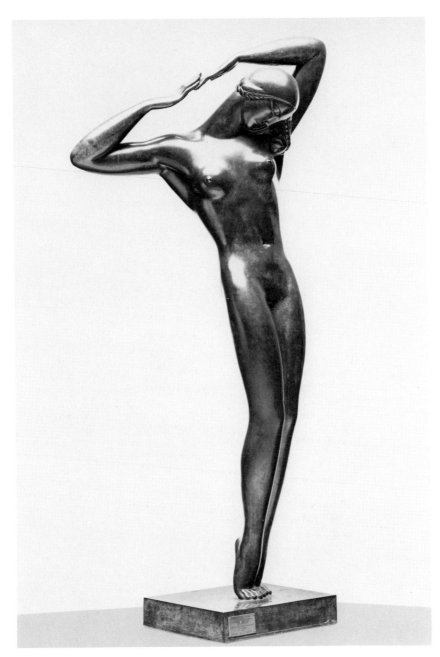

64

Beniamino Bufano
1898?–1970

Beniamino Bufano was an enigmatic and often controversial sculptor who appears to have delighted in confounding both his critics and biographers. Although tradition has held that he was born on October 14, 1898, Erskine Bufano has suggested that his father was born in 1886, and Bufano himself proposed the implausible date of 1910. There is consensus, however, about the place of his birth—San Fele, near Rome, Italy—and his arrival with his family in the United States around 1901. As a child Bufano was interested in drawing, painting, and modeling and between 1913 and 1915 studied at New York's Art Students' League, where he received awards for drawing, sculpture, and composition. He studied with James E. Frazer, whom he claimed to have assisted in the design of the United States "Buffalo" nickel, and worked in the studios of Herbert Adams and Paul Manship. He traveled to San Francisco to work on sculpture for the Panama-Pacific International Exposition, and in 1915 was awarded the five-hundred-dollar Whitney prize at the New York exhibition sponsored by Mrs. Harry Payne Whitney. An extended journey begun in 1917 took him to France, Italy, and eventually to the Orient. During the two years spent in China he studied ceramic art and was befriended by the reformer Sun Yat-Sen, first president of the Chinese Republic. He returned to San Francisco in 1921 where, with the exception of his frequent travel, a stay in Paris during 1928 and 1929, and the maintenance of a studio in Rome, he was to make his home for the remainder of his life.

Although Bufano was exposed to the modern art of his non-traditional contemporaries, his style appears to have evolved independently, and the chaste, essential forms of his figures and animals derived more from the simplicity and idealism of his personal beliefs and convictions than from external influences. Working directly in the ancient mediums of marble, granite, and porphyry, or integrating them with the stainless steel and alloyed metals of twentieth-century technology, he exe-

65

cuted sculpture that embodied his perception of universal truths—peace, the brotherhood of man, and the natural dignity of man and animals. Much of his work is located in or around San Francisco. He was a diminutive man who enjoyed working on a grand scale, but his most ambitious and visionary projects were never realized. Bufano died in San Francisco in 1970.

65 **Female Torso**, ca 1930
Cast stone, 22¼ in (56.5 cm)
Gift of Mr. and Mrs. Budd Rosenberg, 1966.50
A prolific sculptor who was totally lacking in business acumen, Bufano worked in cast stone when he could not afford the more expensive stones that he preferred. Like most of his work, this torso is unsigned and undated; and although it has traditionally been dated circa 1940, it is more likely that it comes from the period between 1922 and 1935 when he carved and exhibited a number of human torsos in solid stone.

Checklist of the Collection

Robert Ingersoll Aitken
1878–1949
Diana
Bronze, 31⅜ in (80 cm)
Museum purchase, 1930.5

Bust of President William McKinley,
1902
Plaster, 24¾ in (62.9 cm)
Gift of the artist, 23979

Margo Allen
b. 1895
Head of a Mayan Woman, 1938–39
Terra-cotta, 11⅞ in (30.2 cm)
Gift of the artist, 1947.16

Alexander Archipenko
1887–1964
Standing Concave, 1925
Chrome-plated brass or bronze, 18¾ in
(47.6 cm)
Bequest of Hélène Irwin Fagan, 1975.5.13

Patrocinio Barela
1908–1964
The High and the Low, ca 1941
Wood, 15 in (38.1 cm)
Ref. no. Z1981.169b

San José, ca 1941
Wood, 15¾ in (40 cm)
Ref. no. Z1981.169a

San Miguel, 1941
Wood, 17¼ in (43.8 cm)
Ref. no. Z1981.169c

Clement J. Barnhorn
1857–1935
Boy Pan with Frog, 1914
Bronze (fountain figure), 48 in (121.9 cm)
Gift of Walter Scott Newhall, 65.27

Paul Wayland Bartlett
1865–1925
Head of a Woman, ca 1910
Bronze, 10⅞ in (27.6 cm)
Gift of Mrs. Armistead Peter III, 1959.23

Philosophy, 1910
Bronze, cast 1927; 16 in (40.6 cm)
Gift of Mrs. Armistead Peter III, 1959.22

Two Fish (Sculpin)
Bronze, 4⅝ in (11.7 cm)
Gift of Mrs. Armistead Peter III, 1959.21

Chester Beach
1881–1956
Beyond, 1911–12
Marble, 62¼ in (158.1 cm)
Gift of Archer M. Huntington, 1926.19

Jacob Berg
working ca 1930
Three Architectural Relief Panels for
The Gray Shop, 1930
Aluminum; side panels, each 75½ × 33 in
(191.8 × 83.8 cm), central panel 75½ ×
44 in (191.8 × 111.8 cm)
Gift of The Oakland Museum, 1979.11.1–3

H. J. Brand
working ca 1870
Emperor Norton
Plaster, with metal stick, 22 in (55.9 cm)
Gift of E. A. Stanford, S392

Beniamino Bufano
1898–1970
Bust of a Chinese Man, 1920–29
Glazed stoneware, 11¾ in (29.8 cm)
Ref. no. Z1981.142

Bust of George W. P. Hunt, 1920–29
Glazed stoneware, 16 in (40.6 cm)
Gift of Mr. and Mrs. Forrest Engelhart, 1938.3

Female Torso, ca 1930
Cast stone, 22¼ in (56.5 cm)
Gift of Mr. and Mrs. Budd Rosenberg, 1966.50

Melvin Earl Cummings
1876–1936
Bust of Reuben Lloyd, 1913
Marble, 26 in (66 cm)
*Gift of the San Francisco Park Commission,
45070*

Bust of Alexander F. Morrison, 1924
Bronze, 14¼ in (36.2 cm)
Gift of William Brobeck, 1925.568

Figure of a Man, 1934
Plaster, 33 in (83.8 cm)
Ref. no. Z1981.176

Bear
Bronze, 7 in (17.8 cm)
Gift of Captain and Mrs. F. K. Perkins, 56.31

Neptune's Daughter
Bronze, 52½ in (133.4 cm)
Gift of William Brobeck, 1930.3

Bust of a Man
Plaster, 36 in (91.4 cm)
Ref. no. Z1981.203

Plaque on E. M. Skinner Co. Organ, with
Relief Portrait of John D. Spreckels, 1924
California Palace of the Legion of Honor

Jo Davidson
1883–1952
Bust of Georges Clemenceau, 1920
Bronze, 15⅛ in (38.4 cm)
Museum purchase, 1930.6

Ida Day Degen
b. 1888
Bust of John D. Barry
Stained plaster, 14⅜ in (36.5 cm)
Gift of James H. McDonough, X1982.15

Cathedral Singer in Niche
Plaster, 13¾ in (34.9 cm)
Ref. no. Z1981.25

Thomas Eakins
1844–1916
An Arcadian, 1883
Bronze relief, cast 1900–30, 8¼ in (21 cm)
*Gift of Mr. and Mrs. John D. Rockefeller 3rd,
1979.7.36*

Harriet Whitney Frishmuth
1880–1980
Fantaisie, 1922
Bronze, 10¼ in (26.7 cm)
Gift of Archer M. Huntington, 1926.18

Karoly Fulop
b. 1898
The Budding Branch
Bronze, 19½ in (49.5 cm)
Gift of the artist, 1940.109

Herbert Gleason
working 1871–1878
Figurehead from the Ship *Centennial*,
ca 1875
Wood, painted white, 86½ in (219.7 cm)
Ref. no. X1971.336

Jonathan Scott Hartley
1845–1912
Bust of George Inness, 1894
Bronze, 24 in (61 cm)
*Dr. T. Edward and Tullah Hanley Memorial
Collection, 69.30.95*

Herbert Haseltine
1877–1962
The Empty Saddle, ca 1921
Gilt bronze, 11⅝ in (29.5 cm)
Gift of Walter Selby McCreery, 1964.111

Suffolk Punch Stallion: Sudbourne
Premier, 1921–24
Gilt bronze with lapis-lazuli, onyx, and
ivory, cast 1937, 22 in (55.9 cm)
Mildred Anna Williams Collection, 1937.10

Cowboy, 1939
Gilt bronze, 12⅞ in (32.7 cm)
Mildred Anna Williams Collection, 1940.102

Cowgirl, 1939
Gilt bronze, 12⅞ in (32.7 cm)
Mildred Anna Williams Collection, 1940.103

James Henry Haseltine
1833–1907
Bust of Mrs. Frank M. Pixley, 1871
Marble, 29¼ in (74.3 cm)
Gift of Miss Vera Pixley, 42624

Bust of Mr. Frank M. Pixley, 1871
Marble, 30¼ in (76.8 cm)
Gift of Miss Vera Pixley, 42625

Malvina Hoffman
1887–1966
Pavlova and Mordkin in "Bacchanale Russe," 1912
Bronze, 14⅛ in (35.9 cm)
Gift of Alma de Bretteville Spreckels, 1959.62

Pavlova in the "Gavotte," 1915
Gilt bronze, 14½ in (36.8 cm)
Gift of Alma de Bretteville Spreckels, 1959.72

Frieze of Pavlova and Mordkin in "Bacchanale Russe," 1917
Aluminum, 48 × 34 (121.9 × 86.4 cm)
Gift of Alma de Bretteville Spreckels, 1959.74

Study for a Female Dancer, 1919
Bronze, 8¾ in (22.2 cm)
Gift of Alma de Bretteville Spreckels, 1959.70

Pavlova and Novikoff in "La Péri," 1921
Bronze, 12¼ in (31.1 cm)
Gift of Alma de Bretteville Spreckels, Theater and Dance Collection, 1962.139

Head of Female Javanese Dancer, 1928
Gilt bronze, 34½ in (87.6 cm)
Gift of Alma de Bretteville Spreckels, 1956.4

Head of Male Javanese Dancer, 1928
Gilt bronze, 30¾ in (78.1 cm)
Gift of Alma de Bretteville Spreckels, 1956.5

Male Liberian Dancer, ca 1930
Bronze, 12⅜ in (31.4 cm)
Gift of Alma de Bretteville Spreckels, 1959.66

Head of Fosuidi, ca 1930
Wood, 15⅝ in (39.7 cm)
Dr. T. Edward and Tullah Hanley Memorial Collection, 69.30.99

Daboa, African Dancer, 1931
Bronze, 14½ in (36.8 cm)
Gift of Alma de Bretteville Spreckels, 1959.69

Balinese Fan Dancer, 1932
Gilt Bronze, 17 in (43.2 cm)
Gift of Alma de Bretteville Spreckels, 1959.71

Egyptian Dancer, 1933
Bronze, 10 in (25.4 cm)
Gift of Alma de Bretteville Spreckels, 1959.65

Male Mongolian Dancer, 1933
Gilt bronze, 19½ in (49.5 cm)
Gift of Alma de Bretteville Spreckels, 1959.64

Uday Shankar, 1933
Gilt bronze, 17½ in (44.5 cm)
Gift of Alma de Bretteville Spreckels, 1959.73

Balinese Bow and Arrow Dancer, 1937
Gilt bronze, 17¾ in (45.1 cm)
Gift of Alma de Bretteville Spreckels, 1959.63

Cambodian Dancer, 1937
Gilt bronze, 14¾ in (37.5 cm)
Gift of Alma de Bretteville Spreckels, 1959.68

Male Madhaven Dancer (Southern India), 1937
Gilt bronze, 15⅞ in (40.3 cm)
Gift of Alma de Bretteville Spreckels, 1959.67

Anna Vaughn Hyatt Huntington
1876–1973
Joan of Arc, 1915
Bronze, cast ca 1922, 12 ft ⅛ in (366.1 cm)
Gift of Archer M. Huntington, 1926.160

El Cid Campeador, 1921
Bronze, cast ca 1927, 14 ft 8¾ in (448.9 cm)
Gift of Herbert Fleishhacker, 1937.11

Bust of Collis P. Huntington, 1927
Bronze, 23½ in (59.7 cm)
Gift of Archer M. Huntington, 1927.23

Bust of Archer M. Huntington, 1927
Bronze, 23¼ in (59.1 cm)
Ref. no. X1982.10

Fawns Playing, 1936
Aluminum, 42 in (106.7 cm)
Gift of the artist, 1939.11

Greyhounds Playing, 1936
Aluminum, 39 in (99.1 cm)
Gift of the artist, 1939.12

Carl Paul Jennewein
1890–1978
Cupid and Crane, 1923
Bronze, 21⅜ in (54.3 cm)
Gift of Archer M. Huntington, 1926.20

Charles Keck
1875–1951
U.S.S. *Maine* Memorial Tablet, 1913
Metal, 12¾ × 17⅝ in (32.4 × 44.8 cm)
Gift of Julius Kahn, 40409

Gaston Lachaise
1882–1935
Bust of Mrs. Lachaise, 1912 - 27
Bronze, cast 1927, 17½ in (44.5 cm)
*Dr. T. Edward and Tullah Hanley Memorial
Collection,* 69.30.113

Albert Laessle
1877–1954
Penguins, 1917
Bronze, 35½ in (90.2 cm)
Museum purchase, 1930.4

Boris Lovet-Lorski
1894–1973
Venus, ca 1925
Bronze, 92½ in (235 cm)
Gift of Mrs. Frank Short, 1958.53

Edward McCartan
1879–1947
Portrait Head, 1934
Terra-cotta, 12⅜ in (31.4 cm)
Gift of Anna Hyatt Huntington, X1982.16

Frederick William MacMonnies
1863–1937
Diana, 1889
Bronze, 29 in (73.7 cm)
William H. Noble Bequest Fund, 1981.15

Paul Manship
1885–1966
Dancer and Gazelles, 1916
Bronze, 32¼ in (81.9 cm)
Bequest of Hélène Irwin Fagan, 1975.5.16

The Spear Thrower, 1921
Bronze, 20 in (50.8 cm)
Bequest of Hélène Irwin Fagan, 1975.5.17

Pietro Mezzara
1820–1883
Relief Portrait of
Justice Stephen J. Field, 1868
Plaster, diameter 16 in (40.6 cm)
Ref. no. X1982.11

Bust of George Gordon, 1869
Painted plaster, 24 in (61 cm)
Gift of John T. Doyle, 40849

Keith Monroe
1917–1973
Monk
Metal, 50 in (127 cm)
Gift of Mr. and Mrs. Nathaniel Owings, 64.49

Joseph J. Mora
1876–1947
Hopi
Marble, 12½ in (31.8 cm)
Ref. no. X1979.18

Hopi Mana
Marble, 12½ in (31.8 cm)
Ref. no. X1979.17

Hilda Morris
b. 1911
Sea Sentry, 1959
Cement on steel, 61 in (154.9 cm)
Gift of Mrs. Ferdinand C. Smith, 1961.26

Elie Nadelman
1882–1946
Ideal Head, ca 1910
Marble, 16 in (40.6 cm)
Bequest of Hélène Irwin Fagan, 1975.5.20

Buck Deer, ca 1915
Bronze, 30 in (76.2 cm)
Bequest of Hélène Irwin Fagan, 1975.5.18

Doe with Lifted Leg, ca 1915
Bronze, 21 in (53.3 cm)
Bequest of Hélène Irwin Fagan, 1975.5.19

Bust of Hélène Irwin Fagan, 1917
Marble, 25⅜ in (64.5 cm)
Bequest of Hélène Irwin Fagan, 1975.5.21

C. S. Newell

working 1886 - 1889
Relief Portrait of Virgil Williams, ca 1886
Two casts
Plaster, 8½ in (21.6 cm)
Gift of Mrs. T. Hampe, 50018
Gift of Mrs. Robert Rembrandt Hill, S49.3

Haig Patigian

1876–1950
Bust of John M. Keith, 1913
Marble, 22½ in (57.2 cm)
Gift of John M. Keith, 40915

Bust of Helen Wills, 1927
Marble, 26 in (66 cm)
Gift of James D. Phelan, 1928.21

Orazio (Horatio) Piccirilli

1872–1954
Black Eagle, ca 1926
Black marble, 36½ in (92.7 cm)
Museum purchase, 1930.8

Hiram Powers

1805–1873
Bust of California, ca 1858
Marble, 26¾ in (67.9 cm)
Gift of M. H. de Young, 42194

Arthur Putnam

1873–1930
All are gifts of Alma de Bretteville Spreckels, unless otherwise noted.
Among the bronzes, the letters a *and* b *following the accession number indicate the existence of a bronze* (a) *having a plaster counterpart* (b).

Felines - Bronze

Combat: Puma and Hunting Dogs, 1905
5⅞ in (14.9 cm), 1924.126

Combat: Puma and Serpents, ca 1906
11 in (27.9 cm), 1924.155

Combat: Puma and Tiger, 1905
10 in (25.4 cm), 1924.170

Combat: Pumas, Deer, and Snake
19 in (48.3 cm), 1924.149

Leopard and Gnu, 1906
8 in (20.3 cm), 1924.175

Leopard Resting, 1908
3 in (7.6 cm), 1933.13.9

Leopard Walking, 1903
11⅛ in (28.3 cm), 1924.160

Lion and Lioness at Play
6 in (15.2 cm), 1924.184a & b

Lion on Boulder, 1900
13¾ in (34.9 cm), 1924.159

Lion Resting with Outstretched Paws, 1910
3 in (7.6 cm), 1924.23

Lion Sitting Up
3½ in (8.9 cm), 1924.116a & b

Lion Watching, 1900
7½ in (19.1 cm), 1932.21.14

Lynx Kitten Crouching, 1900
3¾ in (9.5 cm), 1932.21.12a & b

Lynx Kitten Dozing, Tail Back
Lead (?), 3¼ in (8.3 cm), Z1981.120

Lynx Kitten Skunked, 1909
5¼ in (13.3 cm), 1933.13.12

Lynx Ready to Spring, 1909
4 in (10.2 cm), 1924.109

Lynx Resting, 1909
4 in (10.2 cm), 1933.13.6

Lynx Wounded, 1906
5½ in (14 cm), 1933.13.7

Puma and Lizard
5⅝ in (14.3 cm), 1924.123

Puma Cleaning Up
4½ in (11.4 cm), 1924.130

Puma Examining Footprints, 1908
13¾ in (34.9 cm), 1932.21.1

Puma Licking Paw, 1907
3¾ in (9.5 cm), 1924.115

Puma on Guard
18¾ in (47.6 cm), 1924.169

Puma Reclining, 1908
Three casts
2¼ in (5.7 cm)
*Gifts of Mr. Jacob Stern, 1928.69
and 1928.70
Gift of Ruth Haas Lilienthal, 1975.3.13*

Puma Sleeping
8 in (20.3 cm), 1933.13.2

Pumas Sitting
3 in (7.6 cm), 1932.21.10

Pumas Standing, 1904
7½ in (19.1 cm), 1924.21

Saber-toothed Tiger, 1910
3 in (7.6 cm), 1924.158a & b

Tiger Love
6½ in (16.5 cm), 1924.118

Tiger Reclining (no base)
4 in (10.2 cm), 1933.13.1

Tiger Resting (no base)
4½ in (11.4 cm), 1924.188

Tiger Walking (no base)
7¼ in (18.4 cm), 1924.186

Felines - Plaster

Feline Front (fragment)
2½ in (6.4 cm), Z1982.62

Feline Resting
4 in (10.2 cm), Z1982.67

Feline Seated
4⅛ in (10.5 cm), Z1982.35

Lion and Lioness at Rest
1¾ in (4.4 cm), Z1982.61

Lion and Lioness Watching
14½ in (36.8 cm), 1924.204

Winged Lion
15 in (38.1 cm), Z1982.34

Lion Sleeping
11 in (27.9 cm), 1924.202

Lion Snarling
7 in (17.8 cm), 1924.206

Lynx Kitten Dozing, Tail Front
Two casts, one with base
4¼ in (10.8 cm), Z1982.63a
5¼ in (13.3 cm), Z1982.63b

Lynx Kitten Looking
6½ in (16.5 cm), Z1982.56

Puma on Lookout, 1910
5¼ in (13.3 cm), 1933.13.11

Lynx Kitten Watching, 1910
2 in (5.1 cm), Z1982.86

Puma Resting on Slab
7½ in (19.1 cm), 1924.193

Puma Sitting Up
16½ in (41.9 cm), 1924.194

Puma Watching
6 in (15.2 cm), 1924.200

Other Animals - Bronze

Bear and Ox Skull, 1911
6 in (15.2 cm), 1924.142

Bear Scratching Back
5½ in (14 cm), 1924.138

Bear Scratching Hind Paw
7¼ in (18.4 cm), 1933.13.5a & b

Bear Standing
5⅞ in (14.9 cm), 1924.108

Bear Standing with Ball, 1908
9⅞ in (25.1 cm), 1924.141a & b

Bear Walking, 1910
4⅞ in (12.4 cm), 1924.134a & b

Bear Standing, with Paw on Rock
8¾ in (22.2 cm), 1924.143

Wounded Buffalo and Young
4 in (10.2 cm), 1933.13.3a & b

Buffaloes Fighting, 1900
6½ in (16.5 cm), 1924.127

Colt
12 in (30.5 cm), 1924.16

Buffaloes Fighting

Coyote and Snake, 1909
5½ in (14 cm), 1924.133

Coyote Frightened
7 in (17.8 cm), 1933.13.14

Coyote Sneaking
2½ in (6.4 cm), 1924.140

Dog with Bone, 1904
8¼ in (21 cm), 1924.111

Spread Eagle, 1909
9⅞ in (25.1 cm), 1924.137a & b

Elephant
4¼ in (10.8 cm), 1924.148

Kangaroo
7¼ in (18.4 cm), 1924.129

Kangaroo and Dogs, 1905
12 in (30.5 cm), 1932.21.9

Other Animals - Plaster

Bear on Boulder
11 in (27.9 cm), Z1982.75

Canine and Bird
4 in (10.2 cm), Z1982.60

Dog, 1903
8¼ in (21 cm), 1924.199

Eagle
7 in (17.8 cm), Z1982.69

Squirrel, 1908
7½ in (19.1 cm), 1924.114

Man and Animal Groups - Bronze

Boy and Hare
22½ in (57.2 cm), 1932.21.3

Boy with Lynx
22 in (55.9 cm), 1924.167

Boy Wrestling with Lynx
21½ in (54.6 cm), 1924.168

Combat: Indian, Horse, and Buffalo, 1911
14¾ in (37.5 cm), 1924.163

Combat: Indian and Puma I
7½ in (19.1 cm), 1924.110a & b

Combat: Indian and Puma II
3¾ in (9.5 cm), 1924.174

Combat: Man and Puma I, 1901
7½ in (19.1 cm), 1924.24a & b

Combat: Man and Puma II
5 in (12.7 cm), 1924.122

Combat: Man Fighting Serpent, 1903
10¼ in (26 cm), 1924.135

Combat: Man on Horse Fighting Bear
15½ in (39.4 cm), 1924.189

Combat: Man, Tiger, and Cub
21 in (53.3 cm), 1924.165

Indian and Crouching Puma
8¼ in (21 cm), 1932.21.11

Indian and Slain Puma, 1903
16 in (40.6 cm), 1924.164

Indian Shearing Mountain Sheep, 1903
7 in (17.8 cm), 1924.128a & b

Man and Lion
13 in (33 cm), 1932.21.6

Satyr and Bird
12 in (30.5 cm), 1924.144a & b

Man and Animal Groups - Plaster

Frontiersman Standing with Dog
19½ in (49.5 cm), Z1982.78

Man with Feline (fragment)
5 in (12.7 cm), Z1982.72

The Ploughman
66 in (167.6 cm), 1924.196a and b

The Ploughman (study)
12 in (30.5 cm), 1924.198

Human Figures - Bronze

Study of an Old Man, 1905
28½ in (72.4 cm), 1924.154

Cave Man, 1910
36 in (91.4 cm), 1924.180

Cigar Lighter (Satyr), 1910
19½ in (49.5 cm), 1924.182a & b,c
(two plaster casts)

Contortionist, 1901
10⅞ in (27.6 cm), 1924.177

Hurdler (on wood base)
15 in (38.1 cm), 1924.113a & b

Il Penseroso, 1903
21 in (53.3 cm), 1932.21.7

Il Penseroso

Indian Woman Grinding Corn, 1903
11¼ in (28.6 cm), 1924.172

Left Foot
3¼ in (8.3 cm), 1924.145

Left Hand
2¾ in (7 cm), 1924.190

Left Hand (miniature)
1 in (2.54 cm), 1933.13.18

Male and Female Nude at Rest
4½ in (11.4 cm), 1924.117

Male Nude Reclining: Motif for a Tomb
2½ in (6.4 cm), 1933.13 17

Male Nude Seated with Cloth Draped
from Head, 1903
11 in (27.9 cm), 1924.139

Man Drinking from Roman Water Jug
6½ in (16.5 cm), 1924.147a & b

Man Seated
6½ in (16.5 cm), 1924.178
Note: 1924.207, plaster, is a larger version.

Man with Hands Chained, 1904
7½ in (19.1 cm), 1924.112a & b

Mercury Flying, 1904
15½ in (39.4 cm), 1924.162

Mercury Seated, 1906
8¼ in (21 cm), 1933.13.16

Mother and Son
9⅛ in (23.2 cm), 1924.125

Neptune Reclining
3½ in (8.9 cm), 1924.146

Priest
15 in (38.1 cm), 1924.22

Prospector, 1903
11 in (27.9 cm), 1924.119a & b

Twilight (Venus and Staff), 1909
35 in (88.9 cm), 1932.21.5a & b

Venus Seated
7¼ in (18.4 cm), 1924.136a & b

Winged Female, Standing
9¼ in (23.5 cm), 1924.171

Wounded Hercules
11 in (27.9 cm), 1924.153

Wrestlers
10 in (25.4 cm), 1924.185

Human Figures - Plaster

Bust of an Indian, ca 1903
34 in (86.4 cm), Z1981.150

Female Nude Seated, with Long Braid
6½ in (16.5 cm), Z1982.70

Male Nude Seated with Cloth across Lap,
1904
11½ in (29.2 cm), Z1982.77

Male Nude Seated with Cloth at Feet
16½ in. (41.9 cm), 1924.208

Bearded Man with Cap, 1910
13½ in (34.3 cm), 1924.197

Man Leaning against Tall Monument
9¼ in (23.5 cm), Z1982.66

Man Lying atop Ledge
5½ in (14 cm), Z1982.64

Man Seated
20 in (50.8 cm), 1924.207
Note: 1924.178, bronze, is a smaller version

Man Standing, in Suit, 1903
19¼ in (48.9 cm), 1924.191

Man Standing, with Shovel
9 in (22.9 cm), Z1982.68

Right Hand (on base)
3½ in (8.9 cm), Z1982.71

Soldier Resting against Cannon
10 in (25.4 cm), Z1982.65

Victory (seated man), 1903
9¼ in (23.5 cm), Z1982.76

Architectural Elements - Bronze

Buffalo Mask, 1900
Possibly for a doorknocker
13¾ in (34.9 cm), 1924.176

Coyote Head
2½ in (6.4 cm), 1924.179

Drinking fountain:
Two Lions Resting, 1907
19 in (48.3 cm), 1932.21.4

Fountain: Equestrian Fountain Sketch
6½ in (16.5 cm), 1932.21.8

Fountain figure: The Mermaid, 1909
31½ in (80 cm), 1924.181a & b

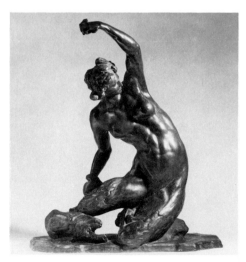

Fountain figure: *The Mermaid*

Lamp bracket: **Squirrel and Pine Cones**
17 in (43.2 cm), 1924.121

Lynx Head
5⅛ in (13 cm), 1924.124

Plaque (round): **The Green Knight**, 1911
Diameter 21 in (53.3 cm), 1924.183

Plaque (rectangular): **Tiger**
5½ in (14 cm), 1924.152

Plaque (rectangular): **Two Tigers**
5½ in (14 cm), 1924.151a

Plaque (rectangular): **Tiger and Bird**
5½ in (14 cm), 1924.150

Puma Mask
Possibly for a doorknocker
11 in (27.9 cm), 1924.173a & b

Puma Mask (with open mouth)
Possibly for a doorknocker
11 in (27.9 cm), 1924.120a & b

Satyr Head
30 in (76.2 cm), 1933.13.15a & b

Architectural Elements - Plaster

Bench, with Lions, 1905
6 in (15.2 cm), 1924.205

Bracket: **Puma Sitting on Capital**
24 in (61 cm), 1924.192a & b
(two plaster casts)

Clock Surround
19¾ in (50.2 cm), Z1981.61
Also see Z1982.3 for similar example.

Clock Surround
19¾ in (50.2 cm), Z1982.3
Also see Z1982.61 for similar example.

Monument, with Lion
15 in (38.1 cm), 1924.201

Panel: **Seated Man**, 1910
14½ in (36.8 cm), Z1981.186

Pediment Study
6¾ in (17.1 cm), Z1982.74

Plaque (square): **Canine Head**
5½ in (14 cm), Z1982.37

Plaque (oval): **Centaurs**
7¾ in (19.7 cm)
Gift of Mr. J. Schoenfeld, 1928.3

Plaque (round): **Child**
19 in (48.3 cm), Z1982.11

Plaque (round): **Hare Eating**
Diameter 8 in (20.3 cm), Z1982.58

Plaque (square): **Lynx Head**
5½ in (14 cm), Z1982.36

Plaque (round): **Lynx Sitting**
Diameter 8 in (20.3 cm), Z1982.57

Plaque (oval): **Man with Dog**
9¾ in (24.8 cm), 1924.203

Plaque (round): **Profile of an Old Person**
11 in (27.9 cm), Z1982.83

Plaque (rectangular): **Tiger Standing**
4 in (10.2 cm), Z1982.55

Plaque (rectangular): **Two Tigers**
5½ in (14 cm), 1924.151b
Note: Image is reverse of 1924.151a

Plaque (round): **William T. Ball, M.D.**
8½ in (21.6 cm), Z1982.56

Relief: **Quatrefoil Surrounding Scales**
19 in (48.3 cm), Z1981.154

Relief: **Woman and Nursing Child**
9½ in (24.1 cm), Z1981.38

Sphinx Head
27 in (68.6 cm), Z1981.60

Sphinx Study
5¾ in (14.6 cm), Z1981.145

Miscellaneous

Plaster Mold
9 in (22.9 cm), Z1982.73

Frederic Remington
1861–1909
The Bronco Buster, 1895
Bronze, 24 in (61 cm)
Gift of Doris Schmiedell and The de Young Museum Foundation, 69.21

William Rimmer
1816–1879
The Dying Centaur, ca 1871
Bronze, 21⅞ in (55.4 cm)
Gift of Mr. and Mrs. John D. Rockefeller 3rd, 1979.7.86

Samuel Anderson Robb
1851–1928
Indian Maiden, ca 1875
For William Demuth & Co.
Painted zinc, 34 in (86.4 cm)
Ref. no. X1982.9

Randolph Rogers
1825–1892
Bust of Milton S. Latham, ca 1860
Marble, 26 in (66 cm)
Gift of Mrs. Milton S. Latham, 45147

Frederick George Richard Roth
1872–1944
Sea Lion, 1904
Bronze, 5⅛ in (13 cm)
Gift of Archer M. Huntington, 1926.15

Bear, 1904
Bronze, 7 in (17.8 cm)
Gift of Archer M. Huntington, 1926.16

Greyhound, 1904
Bronze, 5½ in (14 cm)
Gift of Archer M. Huntington, 1926.17

William Rush, or his studio
1756–1833
Figure of Winter, ca 1825
Polychromed pine, 27 in (68.6 cm)
Art Trust Fund, 1981.7

Charles Marion Russell
1864–1926
Will Rogers on Horseback, ca 1911
Bronze, 11¼ in (28.6 cm)
Gift of Walter Selby McCreery, 1963.21

Rupert Schmid
1864–1932
Bust of William Franklin Herrin, 1898
Marble, 33½ in (85.1 cm)
Gift of the Estate of William F. Herrin, 53761

Bust of Judge Peter Van Clief, 1898
Marble, 30 in (76.2 cm)
Gift of the Estate of William F. Herrin, 53760

Jacques Schnier
b. 1898
Holy Citadel No. 2, 1958
Bronze, 16½ in (41.9 cm)
Gift of Mrs. Jesse W. Lilienthal, 1961.17

Amalia Schulthess
b. 1918
Untitled Abstract, 1962
Bronze, 7½ in (19.1 cm)
Gift of Mrs. Louis Honig, 68.2.2

Franklin Simmons
1839–1913
Bust of General William Tecumseh Sherman, ca 1866
Marble, 21¾ in (55.2 cm)
Gift of George Crocker, 8837

Ralph Stackpole
1885–1974
Bust of John Nicholl, ca 1915
Bronze, 19½ in (49.5 cm)
Gift of Mrs. John Nicholl, 8547

Seated Girl, ca 1915
Stained plaster, 7½ in (19.1 cm)
Gift of William Hammarstrom, 1966.49

David W. Standeford
1830–1906
Seal of the State of California, ca 1876
Wood, 59½ in (151.1 cm)
*California Midwinter International Exposition
of 1894 through M. H. de Young*, 2545

William Wetmore Story
1819–1895
Dalilah, 1877
Marble, 76 in (193 cm)
Gift of M. H. de Young, 49621

King Saul, 1882
Marble, 57 in (144.8 cm)
Gift of M. H. de Young, 49622

Louis H. Sullivan
1856–1924
Architectural Baluster, ca 1900
Painted metal, 39⅛ in (99.4 cm)
*Gift of Carson, Pirie, Scott Co. through The Art
Institute of Chicago*, 1981.68

Leonard Volk
1825–1895
**Reproduction of
Lincoln Life Mask of 1860**
Unglazed porcelain, Sèvres, 1921,
22 in (55.9 cm)
Gift of the French Government, 1925.475

Michael Von Meyer
b. 1894
Head of a Dog, 1935
Terra-cotta, 13 in (33 cm)
Gift of the artist, 1935.6

Unknown Artists
Aztec Warrior
Cast by Louis M. DeRome
Bronze, 44 in (111.8 cm)
Ref. no. X1979.3

California Golden Bear
Gilt wood, 15 in (38.1 cm)
Gift of the California Schuetzen Club, 50918

Bust of Henry Wadsworth Longfellow
Plaster, 33 in (83.8 cm)
*Gift of the Massachusetts Commission to the
Panama-Pacific International Exposition,*
41662

Bust of James Russell Lowell
Plaster, 32¼ in (81.9 cm)
*Gift of the Massachusetts Commission to the
Panama-Pacific International Exposition,*
41661

Bust of David T. Scannell
Bronze, 31¾ in (80.6 cm)
Gift of the San Francisco Fire Department,
37425

Index of Artists

*Catalogue numbers precede page numbers,
which are in italics.*

Production notes:

American Sculpture: The Collection of The Fine Arts Museums of San Francisco was designed by Jack W. Stauffacher, Greenwood Press, San Francisco, California.
Type set in Frutiger-Meridien by Custom Typography Service, and printed by Warren's Waller Press, San Francisco, California.